GO HIGH

—— The Unstoppable Presence and Poise of ——

MICHELLE OBAMA

GO HIGH

—— The Unstoppable Presence and Poise of ——

MICHELLE OBAMA

EDITED BY M. SWEENEY

CASTLE POINT BOOKS

NEW YORK

www.stmartins.com
www.castlepointbooks.com

The Castle Point Books trademark is owned by Castle Point Publishing, LLC.
Castle Point books are published and distributed by St. Martin's Press.

Design by Katie Jennings Campbell

Cover Photo: Tom Williams / CQ-Roll Call Group / Getty Images
Interior Photos: United States Government Works / Official White House Photos
by Samantha Appleton, Sonya N. Hebert, Lawrence Jackson, Chuck Kennedy,
Annie Leibovitz, Amanda Lucidon, and Pete Souza

ISBN 978-1-250-23739-2 (hardcover)

Our books may be purchased in bulk for promotional, educational, or business use.
Please contact your local bookseller or the Macmillan Corporate and Premium
Sales Department at 1-800-221-7945, extension 5442, or by email at
MacmillanSpecialMarkets@macmillan.com.

First Edition: February 2019

10 9 8 7 6 5 4 3 2 1

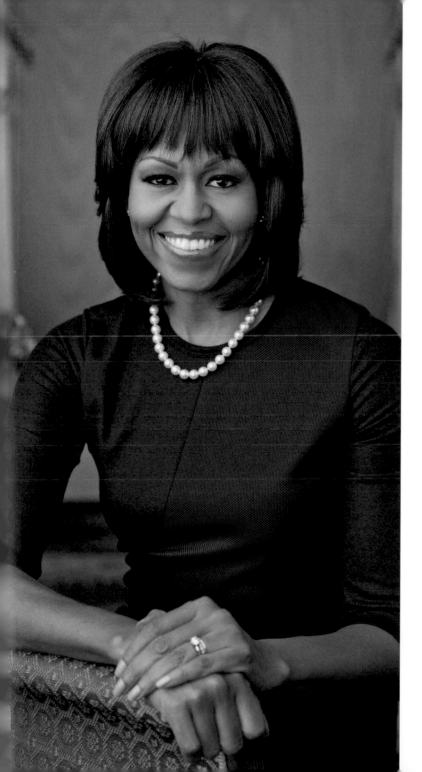

CONTENTS

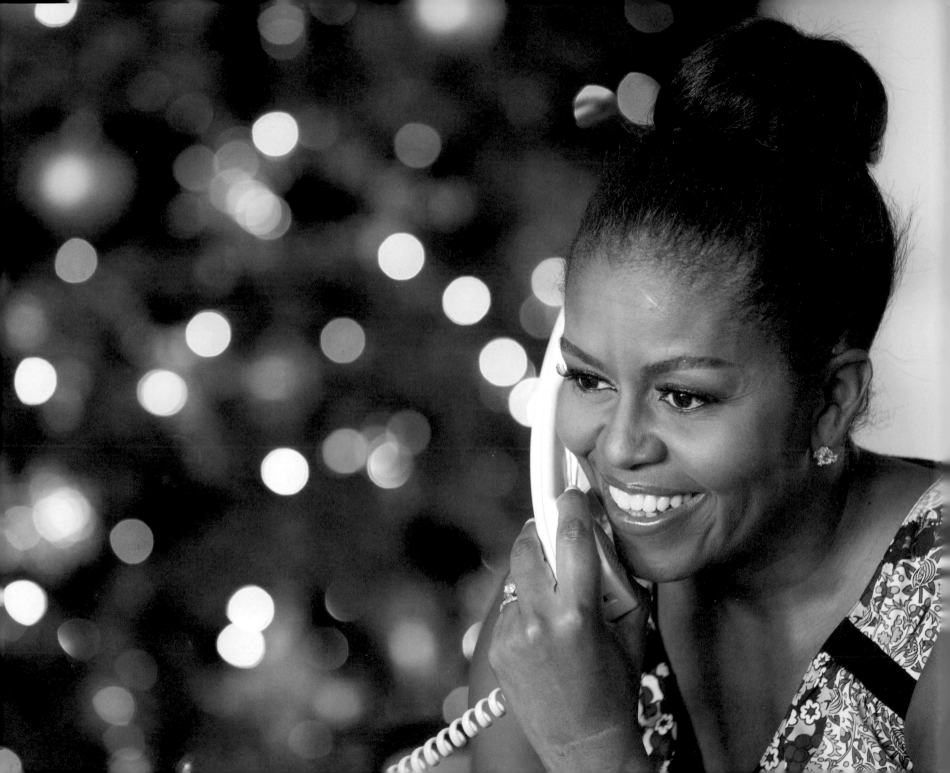

INTRODUCTION

Michelle Obama spent her tenure as First Lady of the United States modeling the lessons she learned in her lifetime: Go high when others go low, give back to your community, have a little fun, and find the strength to push through adversity. A graduate of Princeton University and Harvard Law School, a lawyer, a loving mother and wife, and the first African American First Lady, Michelle Obama is both a bridge builder and a force to be reckoned with. She used her global platform as a catalyst for good, but it was her charm, warmth, honesty, and integrity that made her shine.

What Michelle Obama championed from the White House continues to inspire us today: she remains an advocate for health, hope, and education for children everywhere and shows us that Americans from all walks of life and political affiliations can come together and rise above the fray. On each page of this photographic tribute, you will find Michelle Obama in moments of joy, laughter, compassion, and courage, along with the most inspiring words from her speeches and public appearances. *Go High* celebrates Michelle Obama's vigorous hope and fervent determination that if we aim a little higher and lift up those around us, we can create a brighter future.

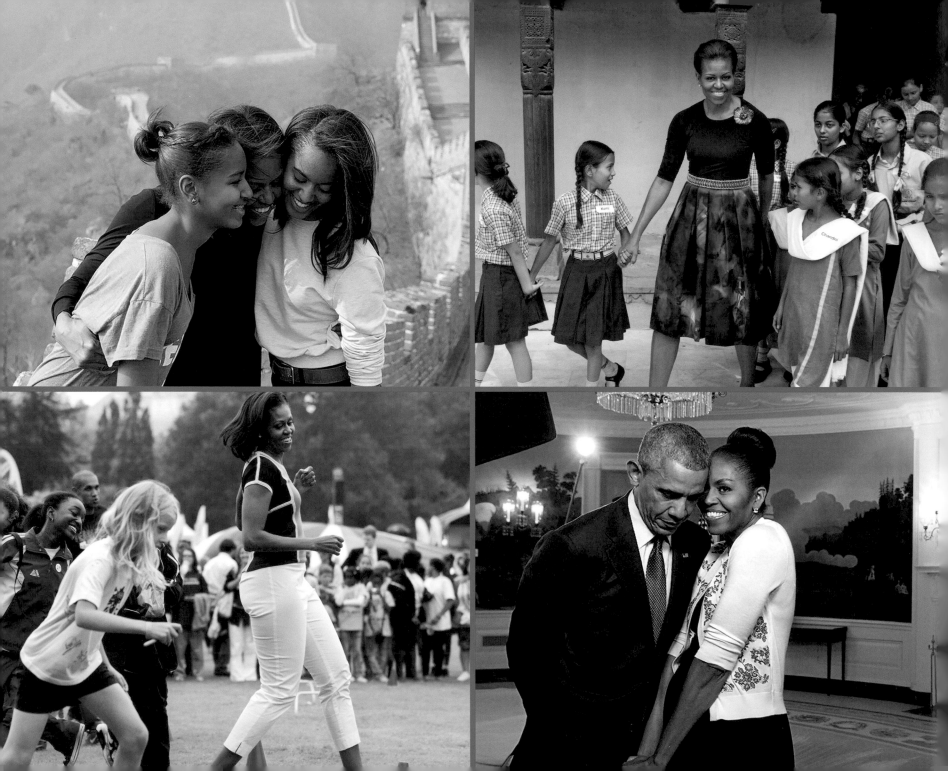

HEART

> **"** I am an example of **WHAT IS POSSIBLE** WHEN GIRLS from the very beginning of their lives ARE LOVED and nurtured by people around them. **"**

—Elizabeth Garrett Anderson School, April 2, 2009

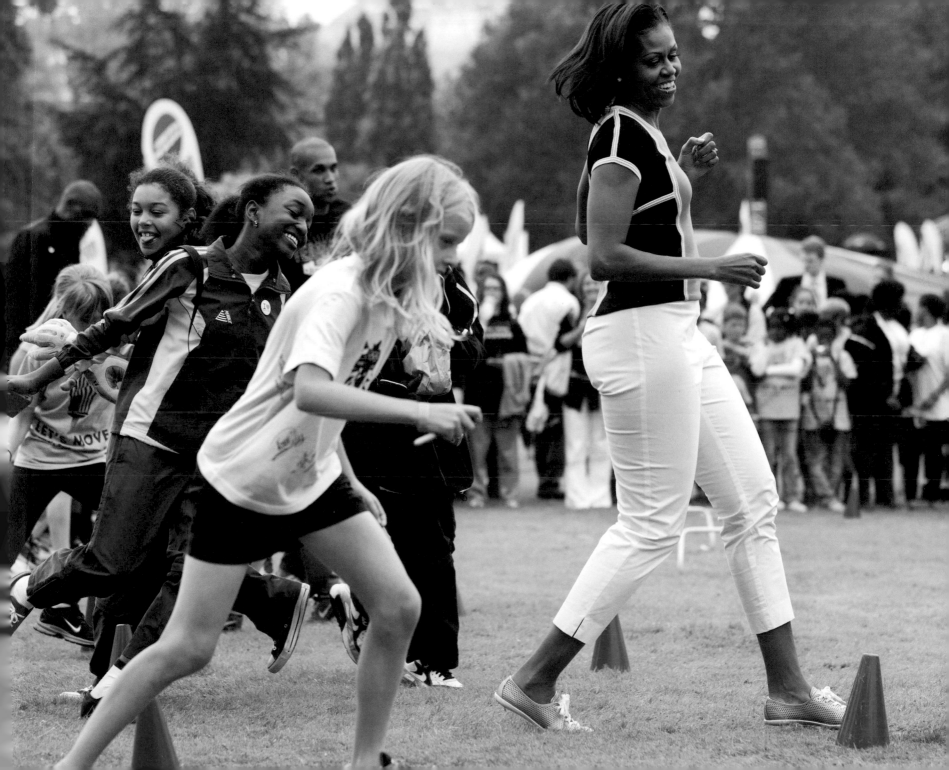

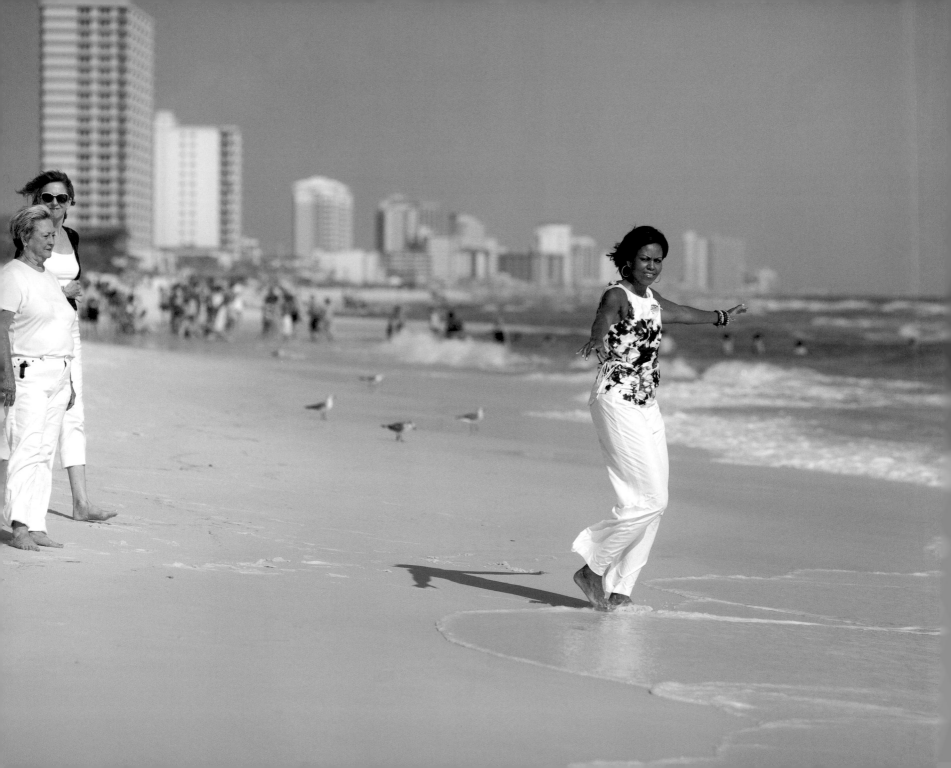

"SUCCESS isn't about how your life looks to others. It's about how it feels to you. We realized that being successful isn't about being impressive,

IT'S ABOUT BEING INSPIRED.

That's what it means to be true to yourself.**"**

—Oregon State University, June 17, 2012

"The only limit to THE HEIGHT OF YOUR ACHIEVEMENTS IS THE REACH OF YOUR DREAMS and your willingness to **WORK HARD FOR THEM.**"

—Democratic National Convention, August 25, 2008

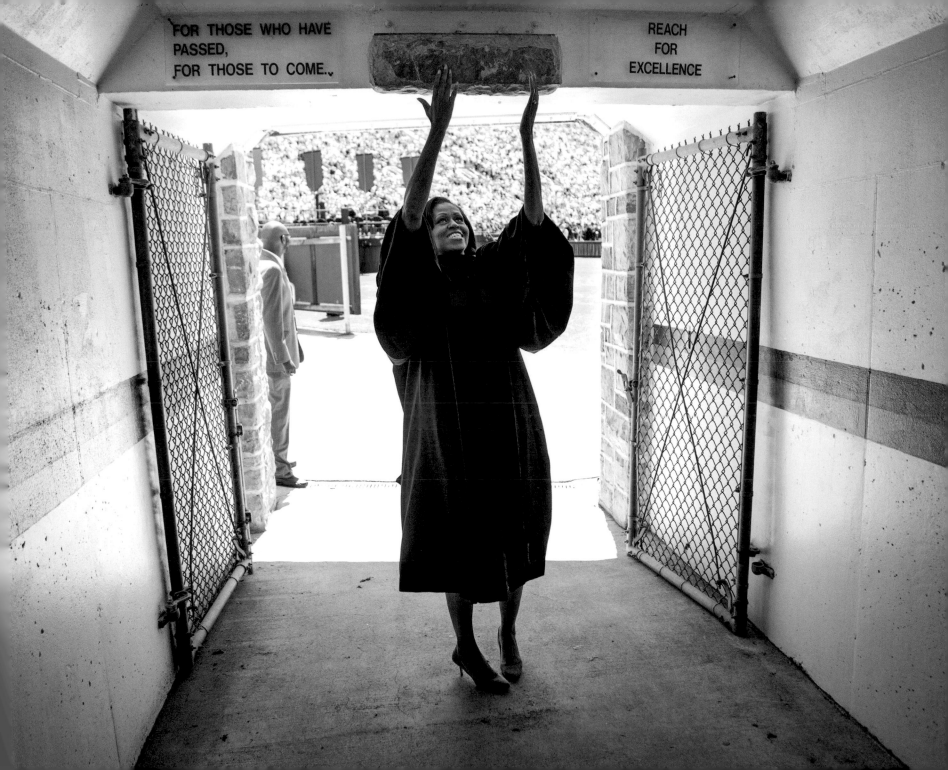

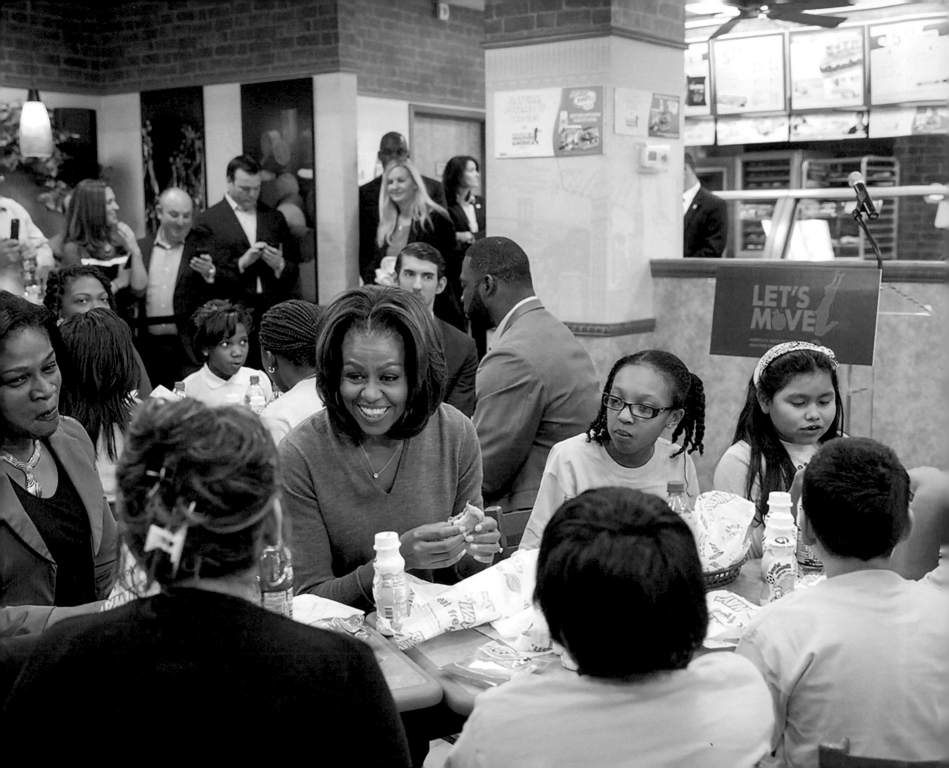

"CHANGE ISN'T EMOTION.

It's real work and organization and strategy—
. . . You pull people in with inspiration,
but then you have to roll up your sleeves
and you've got to make sacrifices
and you have got to have structure. "

—Interview with Katie Couric, *CBS News*, February 14, 2008

" We should always have three friends in our lives—ONE WHO WALKS AHEAD who we look up to and we follow; **ONE WHO WALKS BESIDE US,** who is with us every step of our journeys; and then, ONE WHO WE REACH BACK FOR and we bring along after we've cleared the way. "

—National Mentoring Summit, January 15, 2011

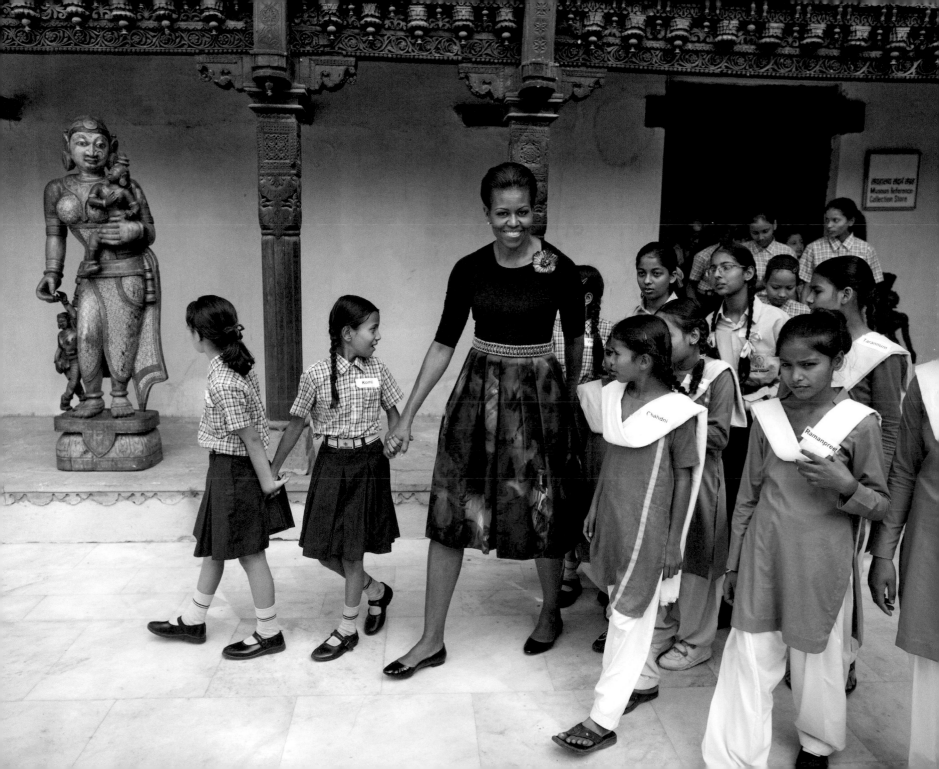

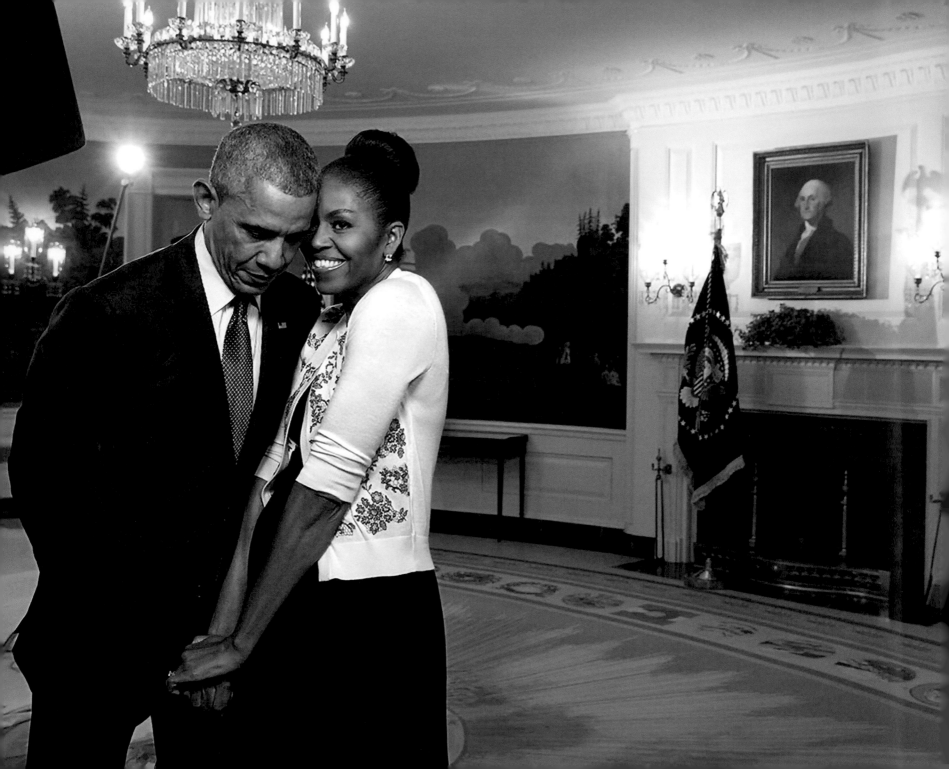

" It has to be a true partnership, and you have to really, **REALLY LIKE AND RESPECT THE PERSON YOU'RE MARRIED TO** because it is a hard road. "

—Interview on *The Oprah Winfrey Show*, May 2, 2011

" Young people,

DON'T BE AFRAID.

Be focused, be determined, be hopeful,

BE EMPOWERED. **"**

—Final remarks as First Lady, School Counselor of the Year
Reach Higher Event, January 6, 2017

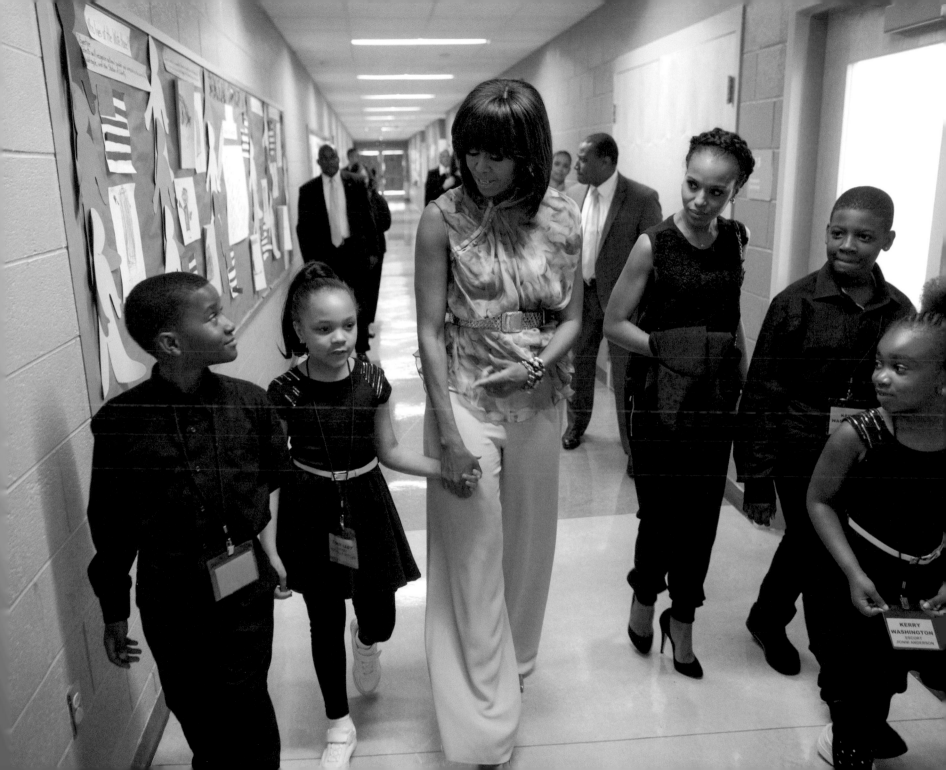

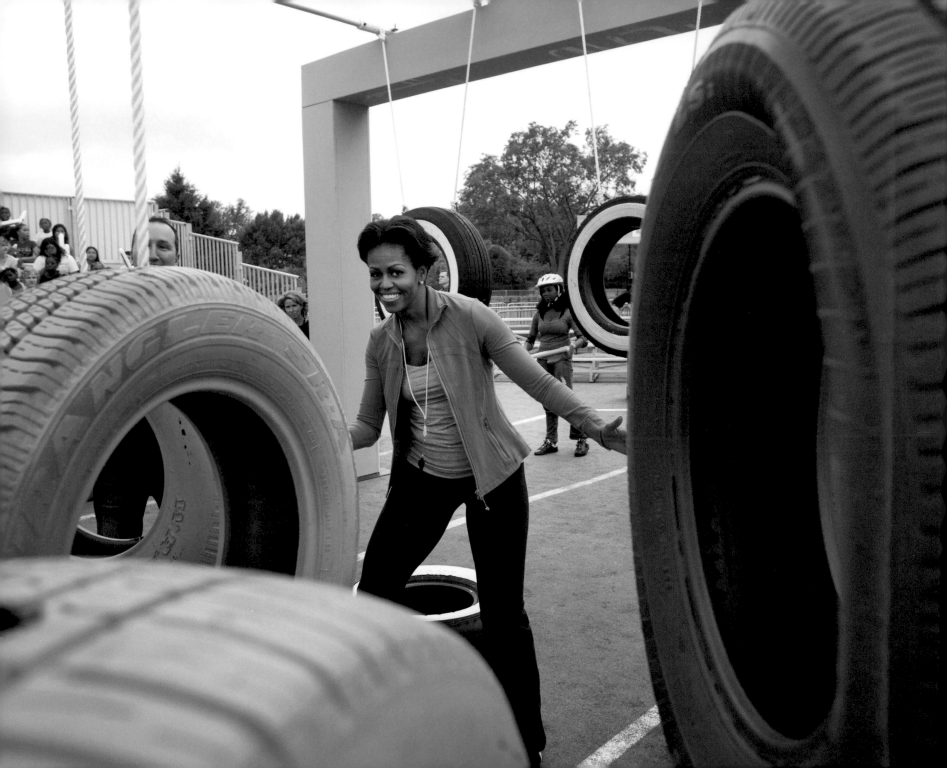

"LIVE LIFE ON YOUR OWN TERMS...

Anyone who has achieved anything in life, knows challenges and failures are components of success."

—Black Girls Rock!, *BET*, March 28, 2015

> **"ALWAYS STAY TRUE TO YOURSELF** and never let what somebody else says distract you from **YOUR** goals. **"**

—Interview with *Marie Claire*, October 22, 2008

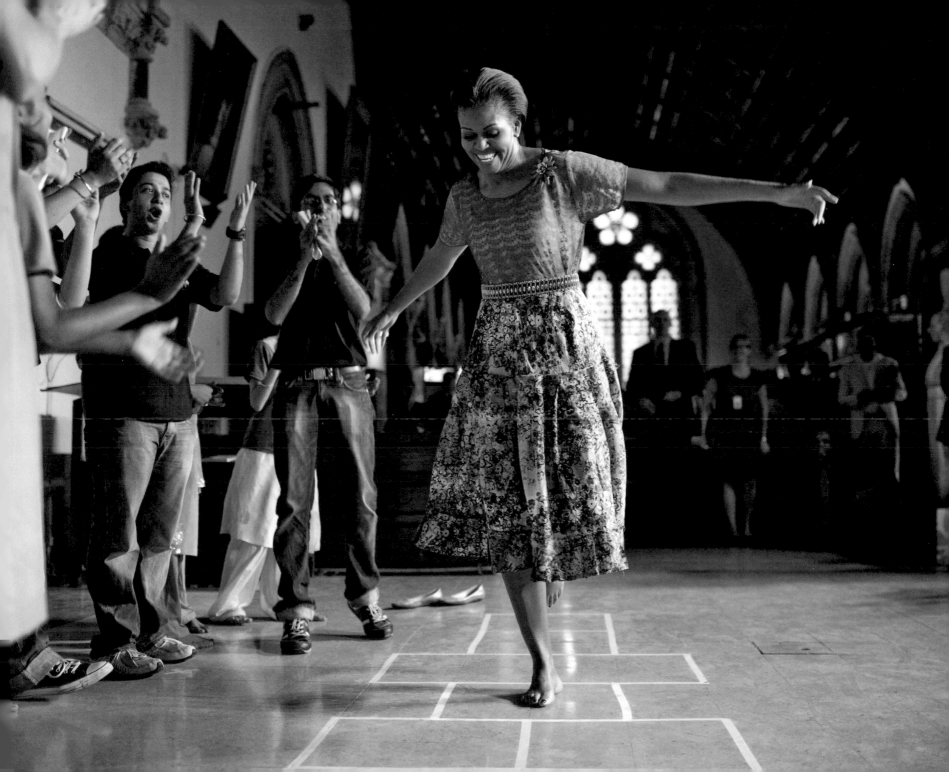

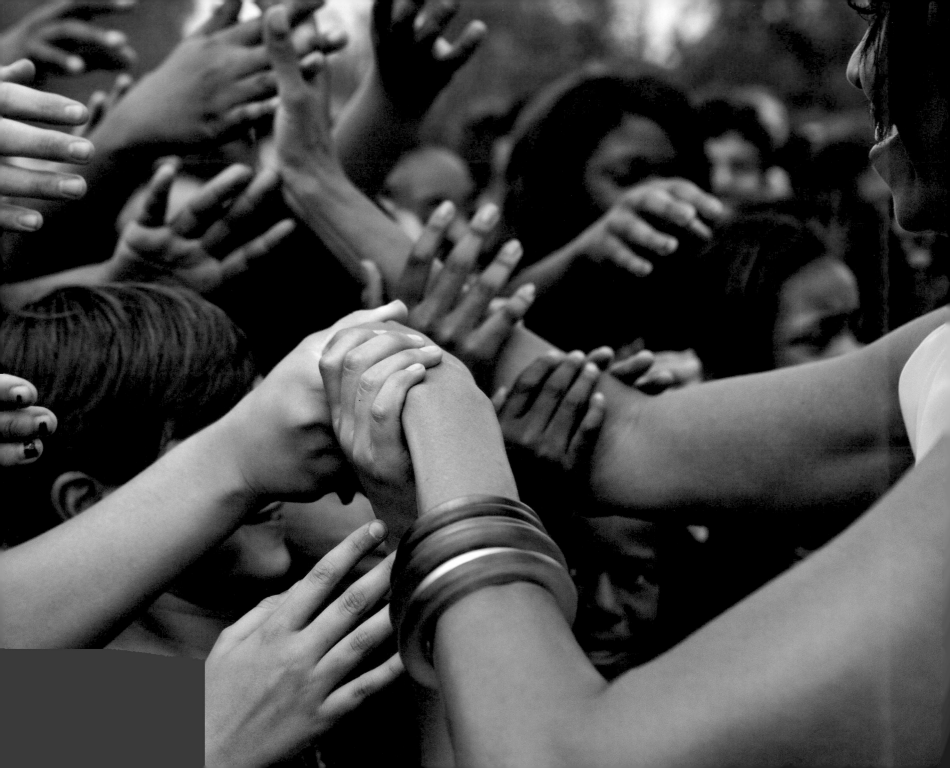

"KNOW THAT **THIS COUNTRY BELONGS TO YOU—** **TO ALL OF YOU,** FROM EVERY BACKGROUND AND WALK OF LIFE. "

—Final remarks as First Lady, School Counselor of the Year
Reach Higher Event, January 6, 2017

"WE ROCK!

NO MATTER WHO YOU ARE,
no matter WHERE YOU COME FROM,
YOU are beautiful, YOU are powerful,
YOU are brilliant, YOU are funny!"

—Black Girls Rock!, *BET*, March 28, 2015

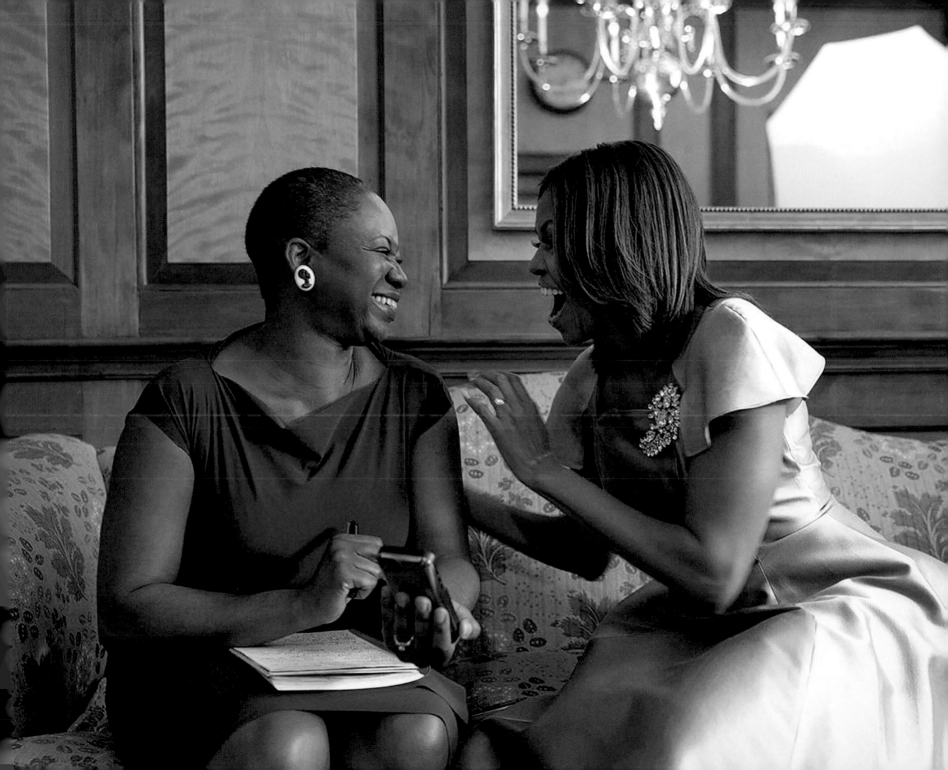

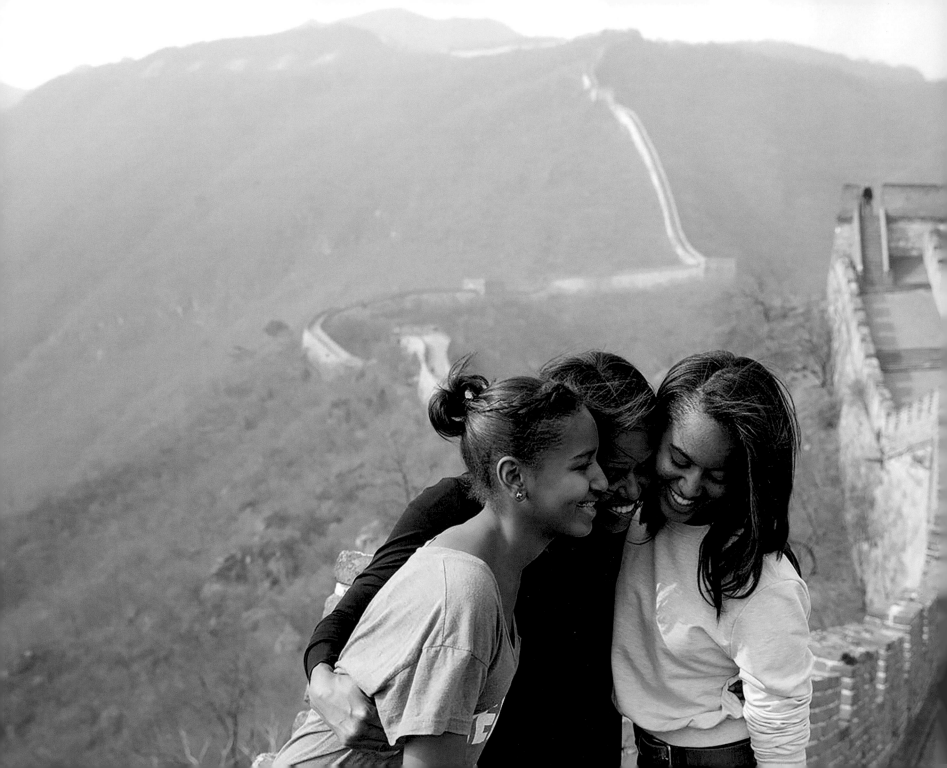

"While that may not be the first thing that some folks want to hear from an Ivy-league educated lawyer, it is truly who I am. So for me, **BEING MOM-IN-CHIEF IS, AND ALWAYS WILL BE, JOB NUMBER ONE.**"

—Tuskegee University, May 9, 2015

"JUST LIVE YOUR LIFE.
LIVE IT OUT LOUD."

—Interview with Oprah Winfrey, *CBS*, December 19, 2016

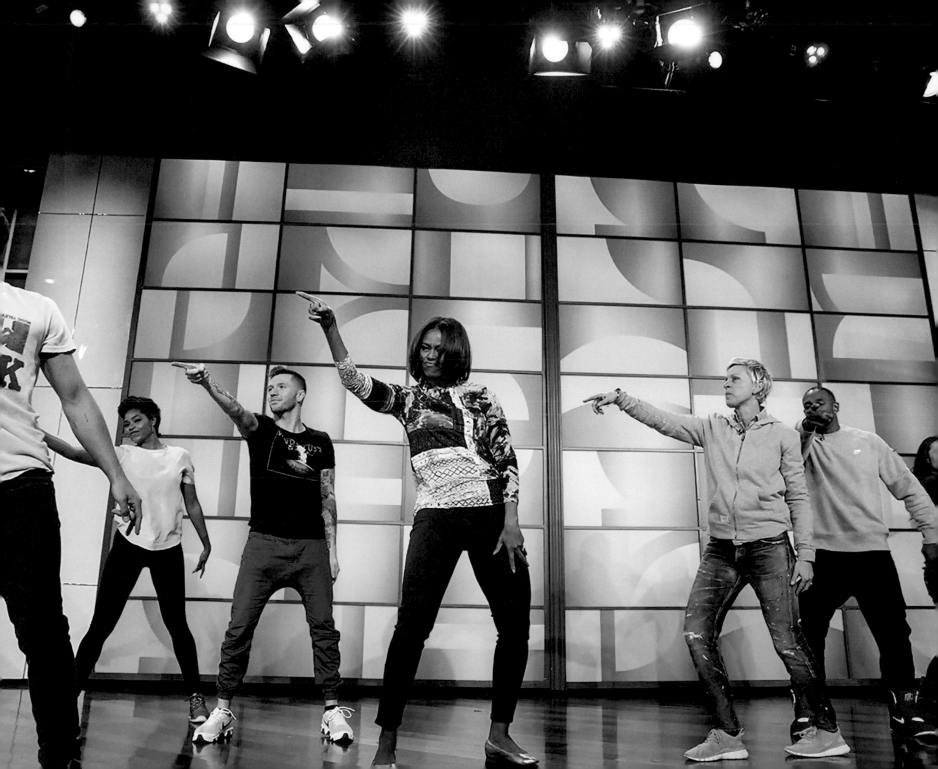

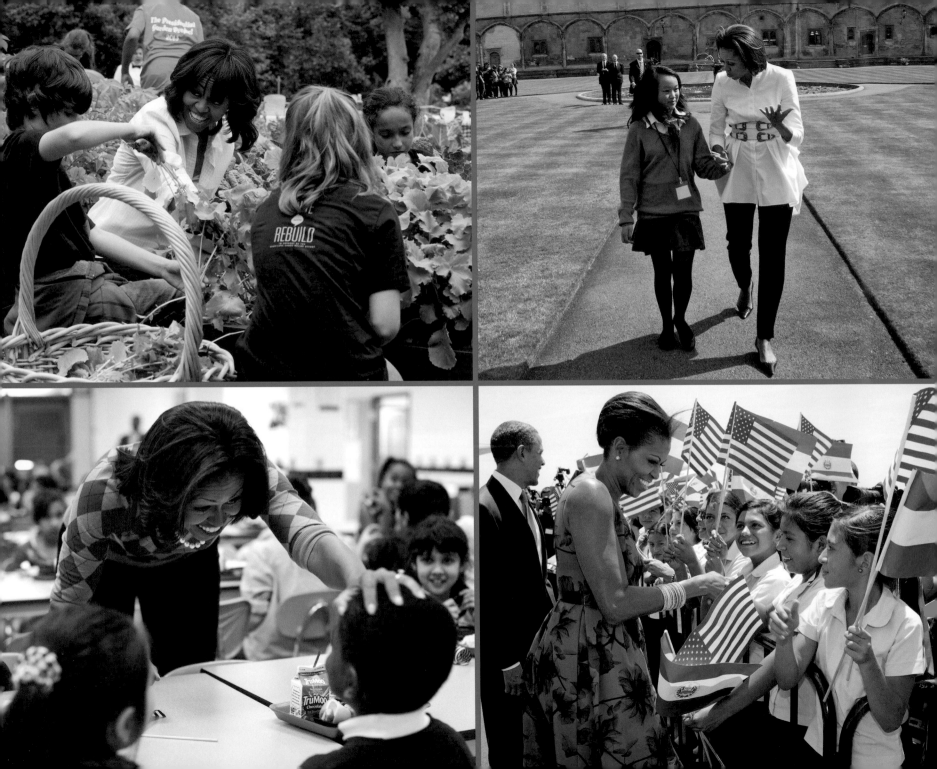

HELP

> " When you've worked hard, and done well, and walked through that doorway of opportunity, **YOU DO NOT SLAM IT SHUT BEHIND YOU.** You reach back, and you give other folks the same chances that helped you succeed. "

—Democratic National Convention, September 4, 2012

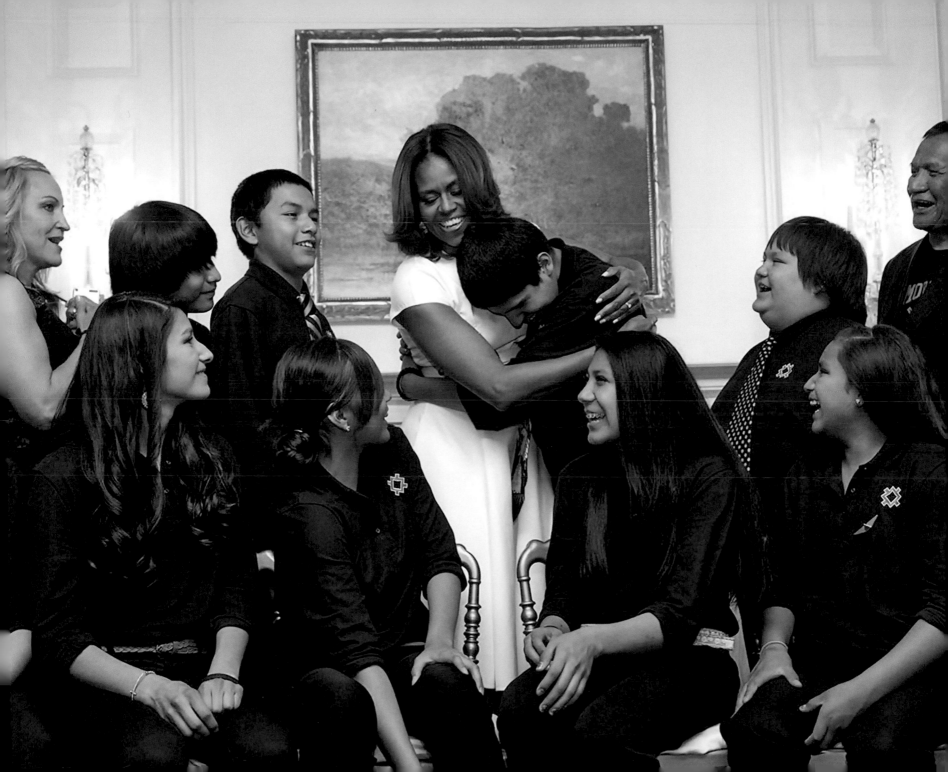

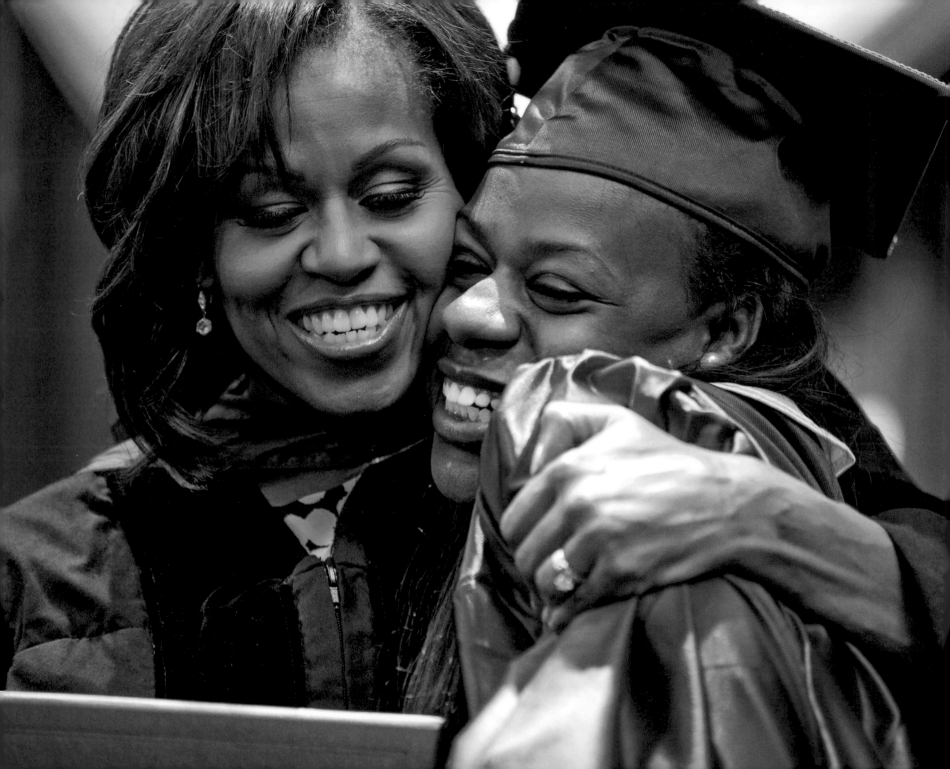

"NO COUNTRY CAN EVER TRULY FLOURISH IF IT STIFLES THE POTENTIAL OF ITS WOMEN."

—Summit of the Mandela Washington Fellowship
for Young African Leaders, July 20, 2014

"NOTHING IS MORE IMPORTANT THAN THE HEALTH AND WELL-BEING OF OUR CHILDREN.

Nothing. And our hopes for their future should drive every single decision that we make. "

—Signing of the Healthy, Hunger-Free Kids Act, December 13, 2010

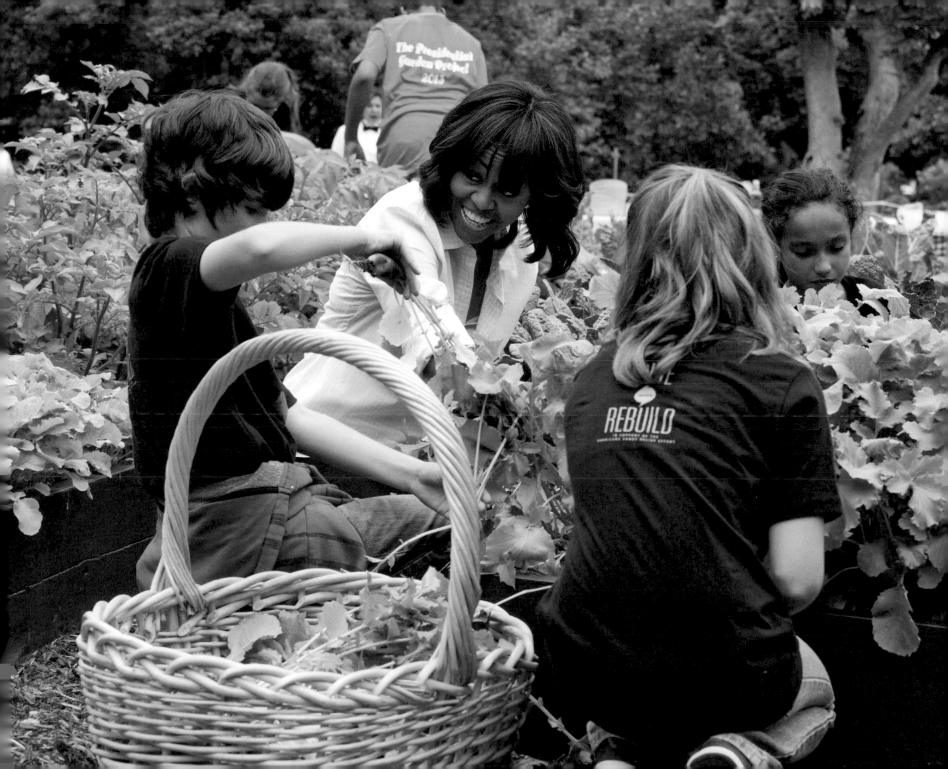

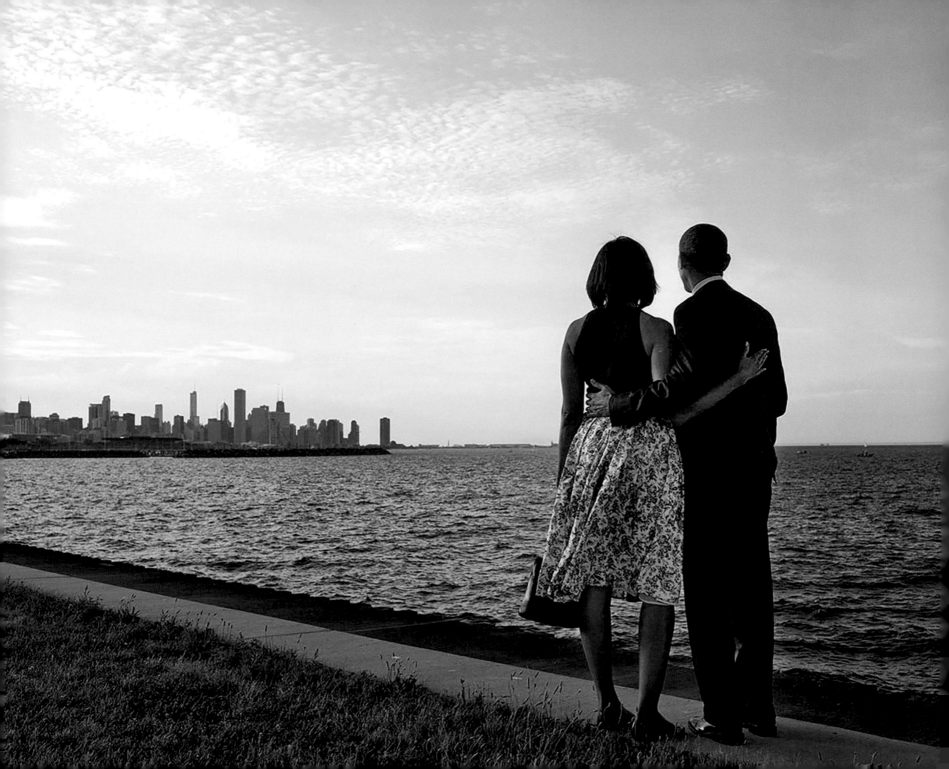

" This time, in this great country—
where a girl from the South Side of Chicago
can go to college and law school,
and the son of a single mother from Hawaii

CAN GO ALL THE WAY
TO THE WHITE HOUSE—

we committed ourselves to building
the world as it should be. "

—Democratic National Convention, August 25, 2008

> "You need to prepare yourself to **BE INFORMED AND ENGAGED** as a citizen, to serve and to lead, to stand up for our proud American values and to honor them in your daily lives."

—Final remarks as First Lady, School Counselor of the Year
Reach Higher Event, January 6, 2017

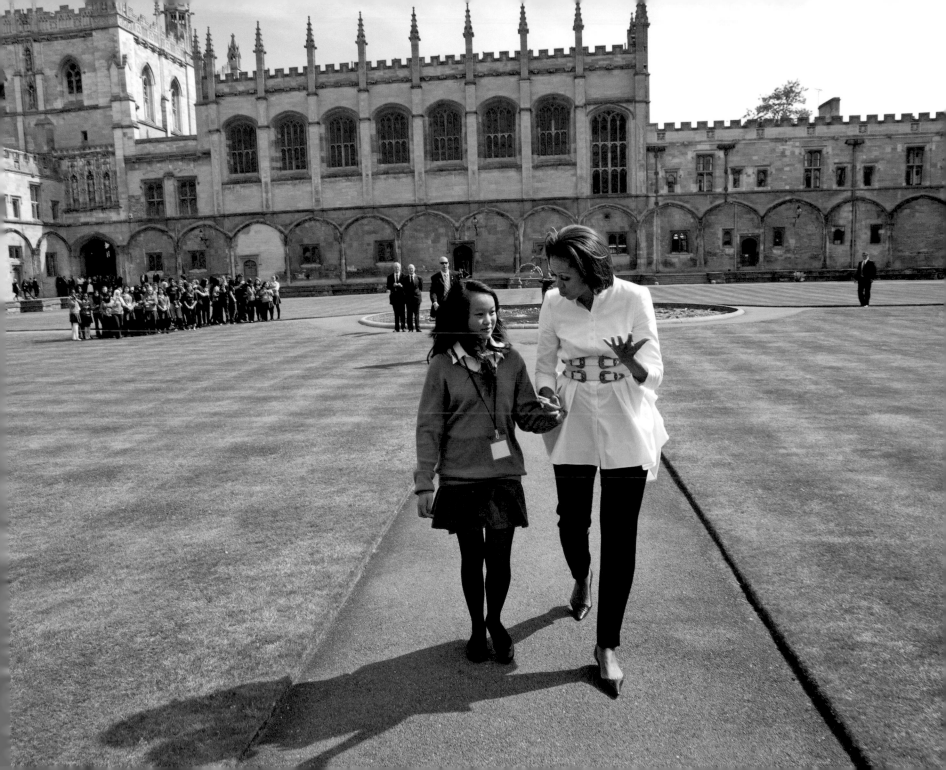

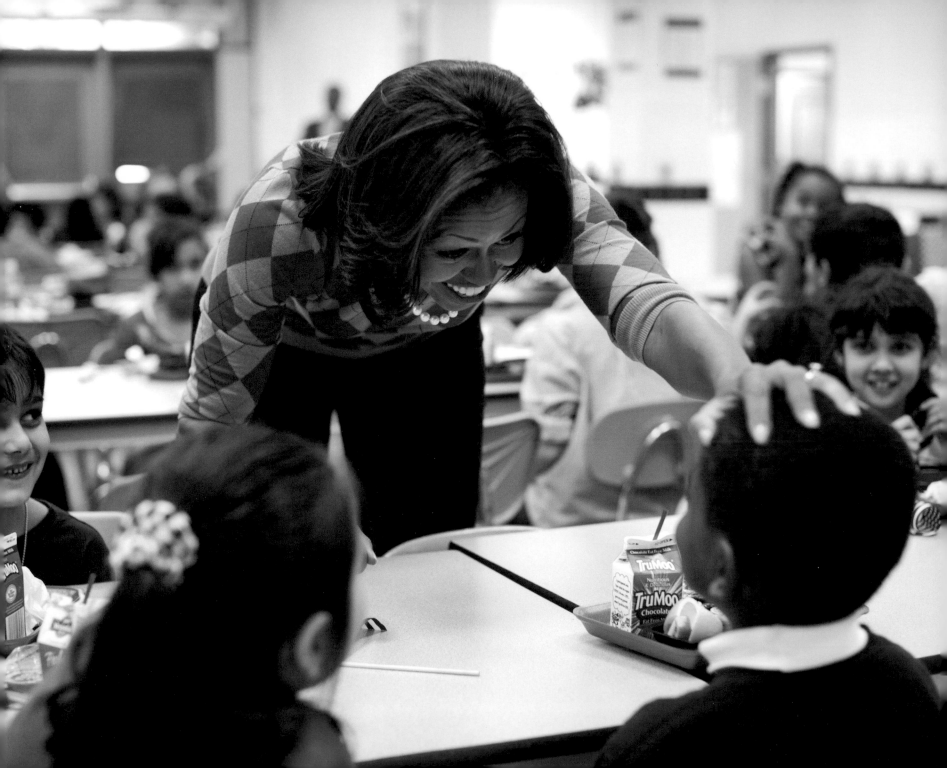

"WHO DO YOU WANT TO BE?
What inspires you? How do you want to give back?
And then I want you to take a deep breath and
TRUST YOURSELVES to chart your
own course and make your mark on the world. **"**

—Tuskegee University, May 9, 2015

> # "THE DIFFERENCE BETWEEN A BROKEN COMMUNITY AND A THRIVING ONE IS THE **PRESENCE OF WOMEN WHO ARE VALUED.**"

—State Department Women of Courage Award, March 11, 2009

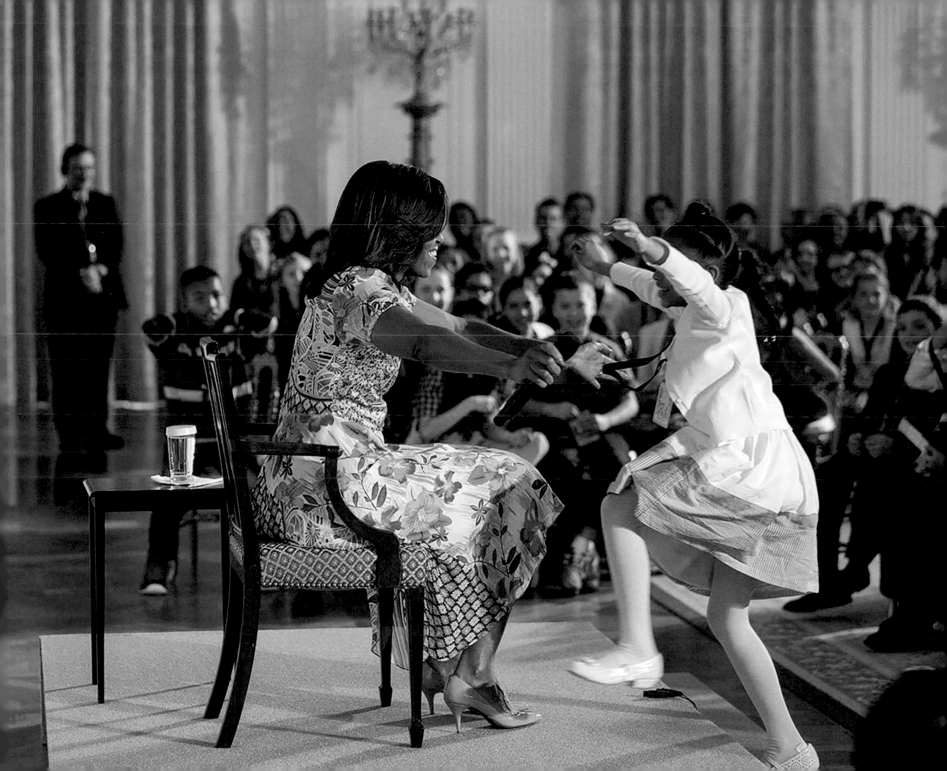

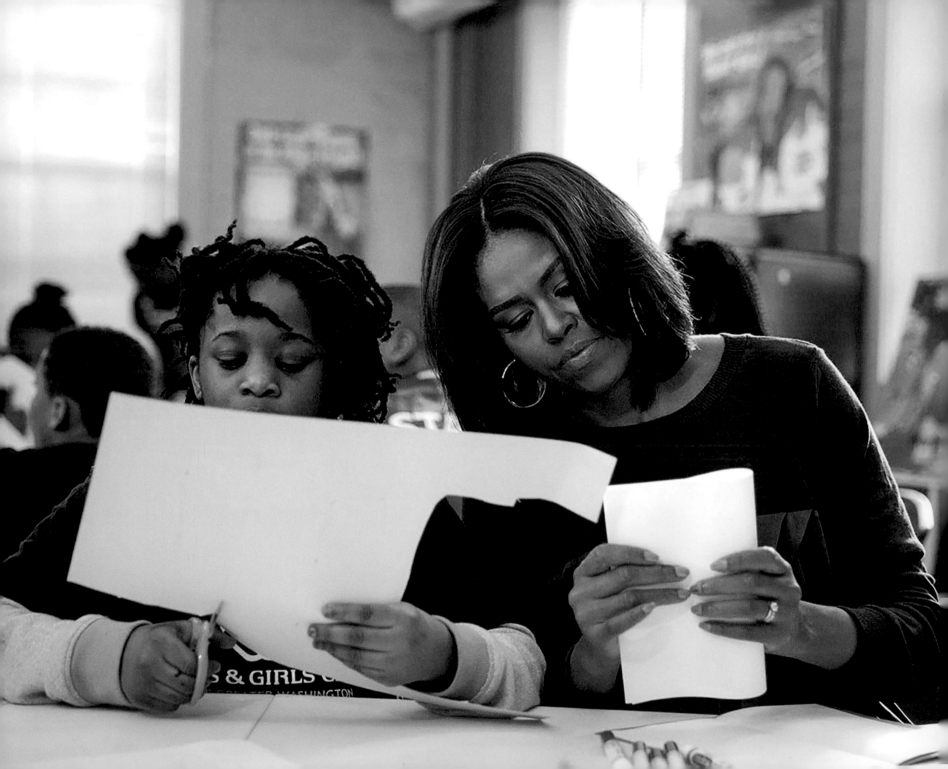

"TRUE LEADERSHIP OFTEN HAPPENS WITH THE SMALLEST ACTS,

in the most unexpected places, by the most unlikely individuals."

—Young African Women Leaders Forum, June 22, 2011

"**WE GIVE BACK EVEN WHEN WE'RE STRUGGLING OURSELVES** BECAUSE WE KNOW THAT THERE IS ALWAYS SOMEONE WORSE OFF. AND THERE BUT FOR THE GRACE OF GOD GO I."

—Democratic National Convention, July 25, 2016

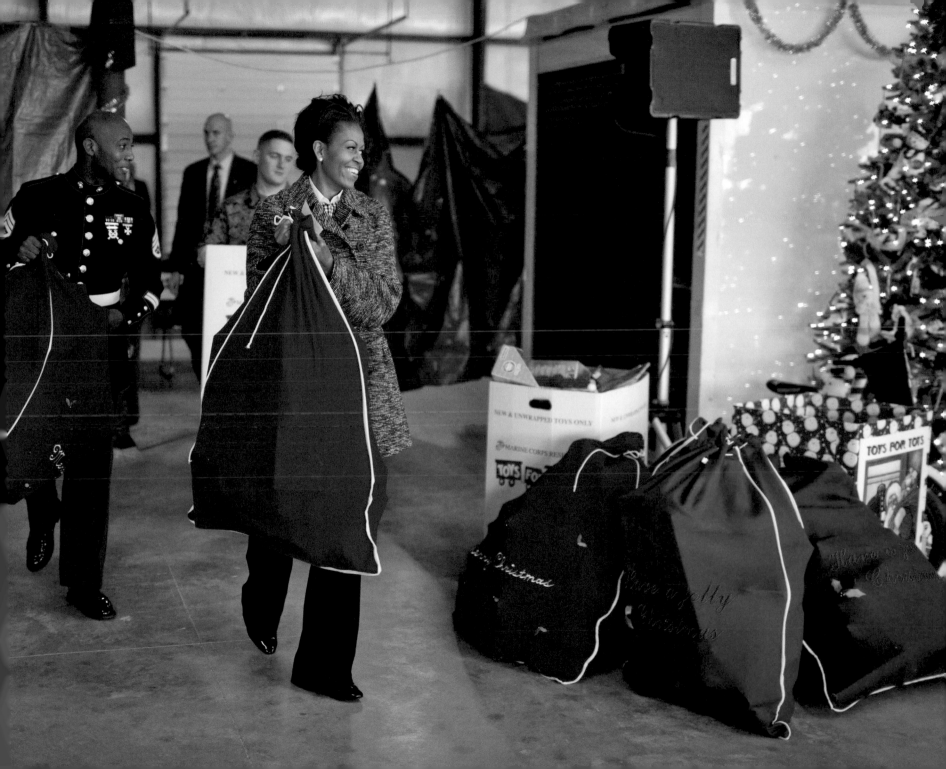

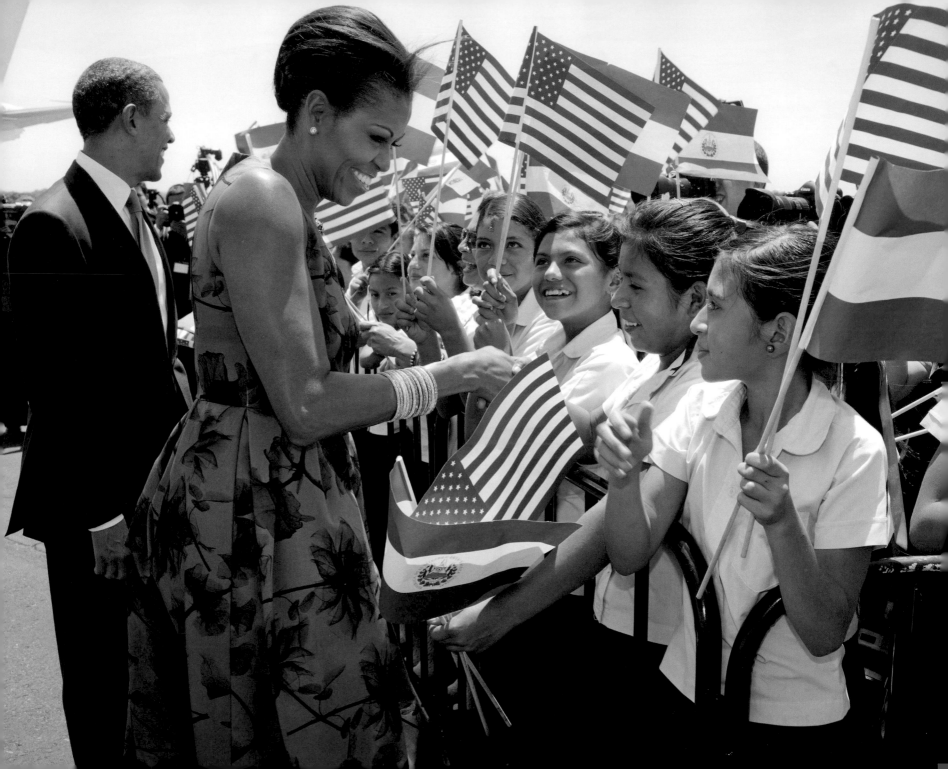

"**EVERY GIRL,**
NO MATTER WHERE SHE LIVES, DESERVES THE OPPORTUNITY TO DEVELOP THE PROMISE INSIDE OF HER."

—Op-Ed, *Financial Times*, June 15, 2015

"HOW HARD YOU WORK MATTERS MORE THAN HOW MUCH YOU MAKE...

HELPING OTHERS MEANS MORE THAN JUST GETTING AHEAD."

—Democratic National Convention, September 4, 2012

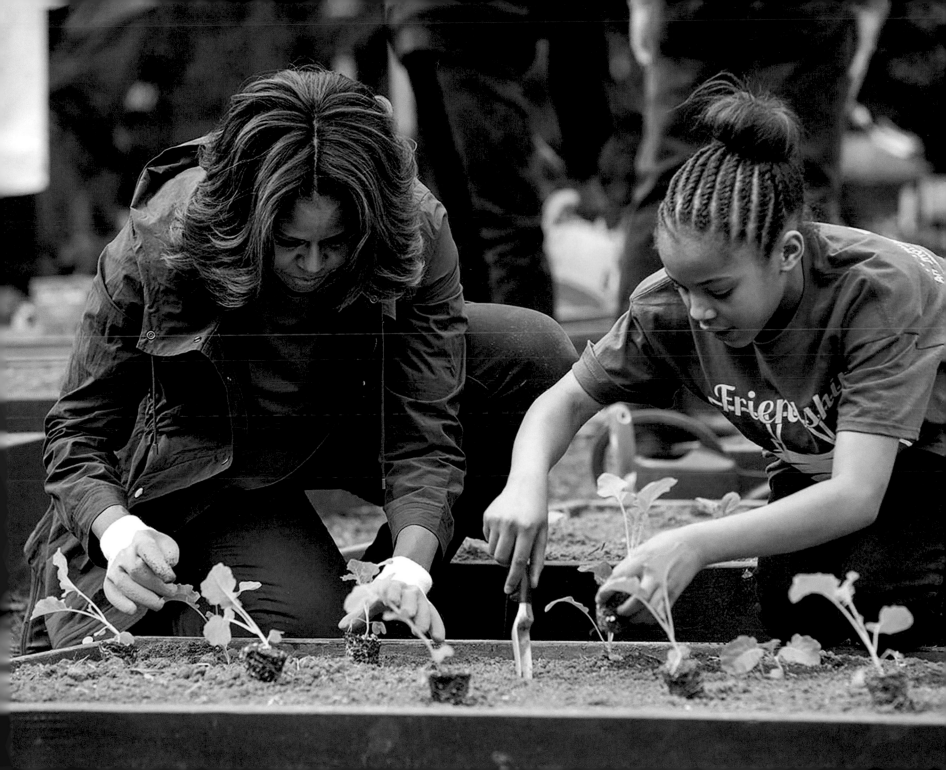

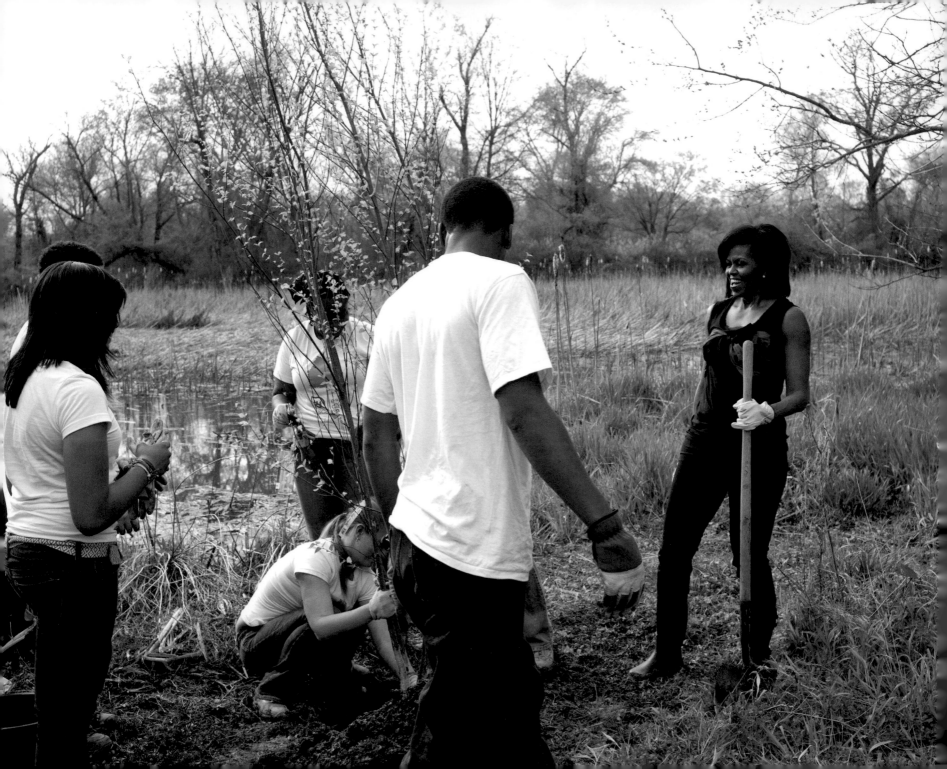

"TOGETHER—
WE CAN OVERCOME
ANYTHING
THAT STANDS IN
OUR WAY."

—Tuskegee University, May 9, 2015

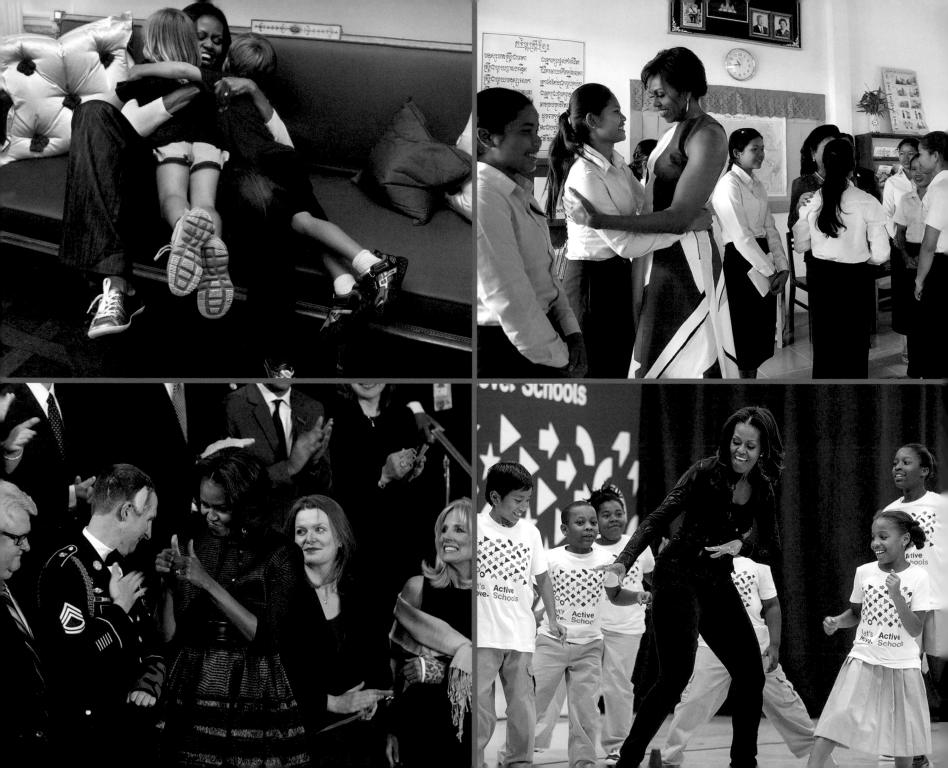

HOPE

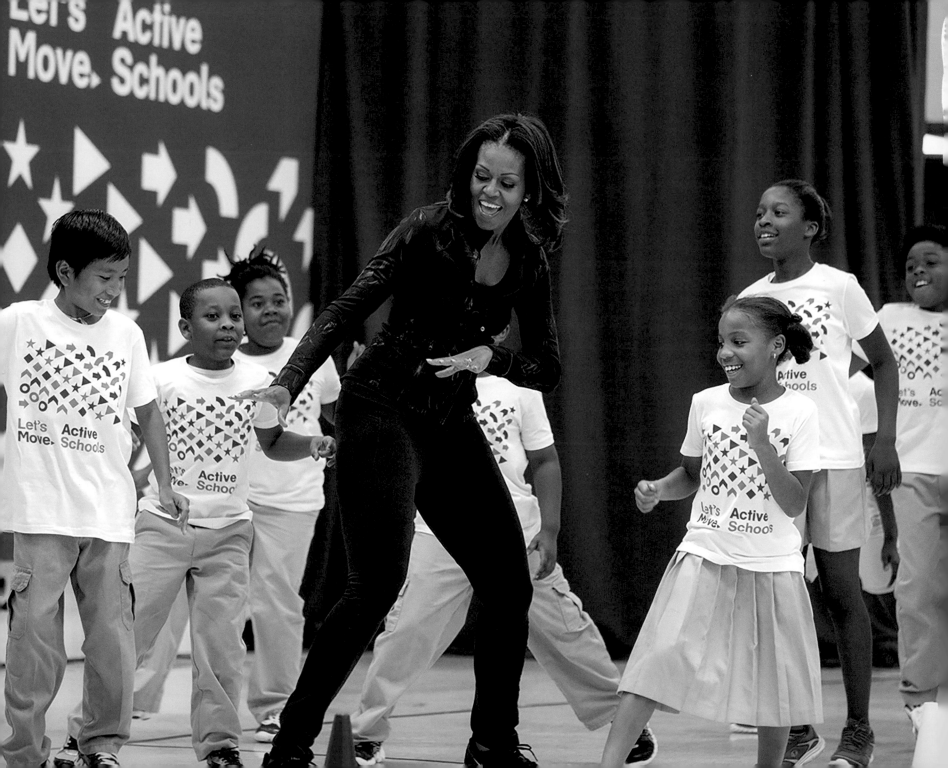

> " IF WE WANT MATURITY,
> WE HAVE TO BE MATURE.
> **IF WE WANT A NATION
> THAT FEELS HOPEFUL,**
> THEN WE HAVE TO SPEAK
> IN HOPEFUL TERMS.
> **WE HAVE TO MODEL
> WHAT WE WANT.** "

—Interview with Oprah Winfrey, *CBS*, December 19, 2016

" You will not always be able to solve all the world's problems all at once. But **DON'T EVER UNDERESTIMATE THE IMPACT YOU CAN HAVE,** because history has shown us that **COURAGE CAN BE CONTAGIOUS,** and hope can take on a life of its own. **"**

—Young African Women Leaders Forum, June 22, 2011

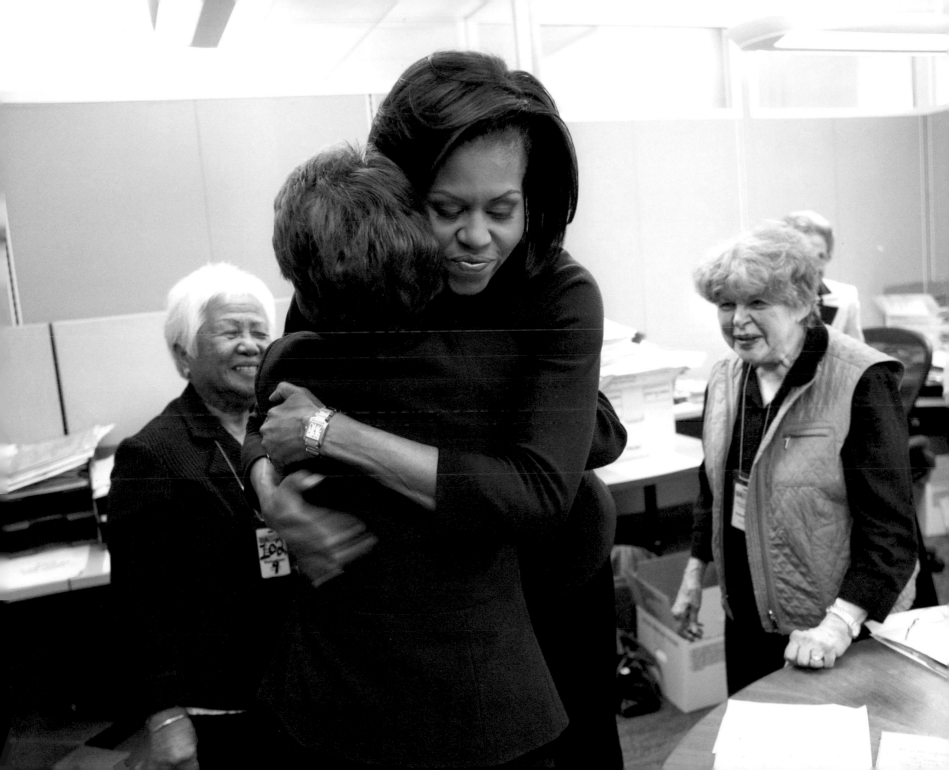

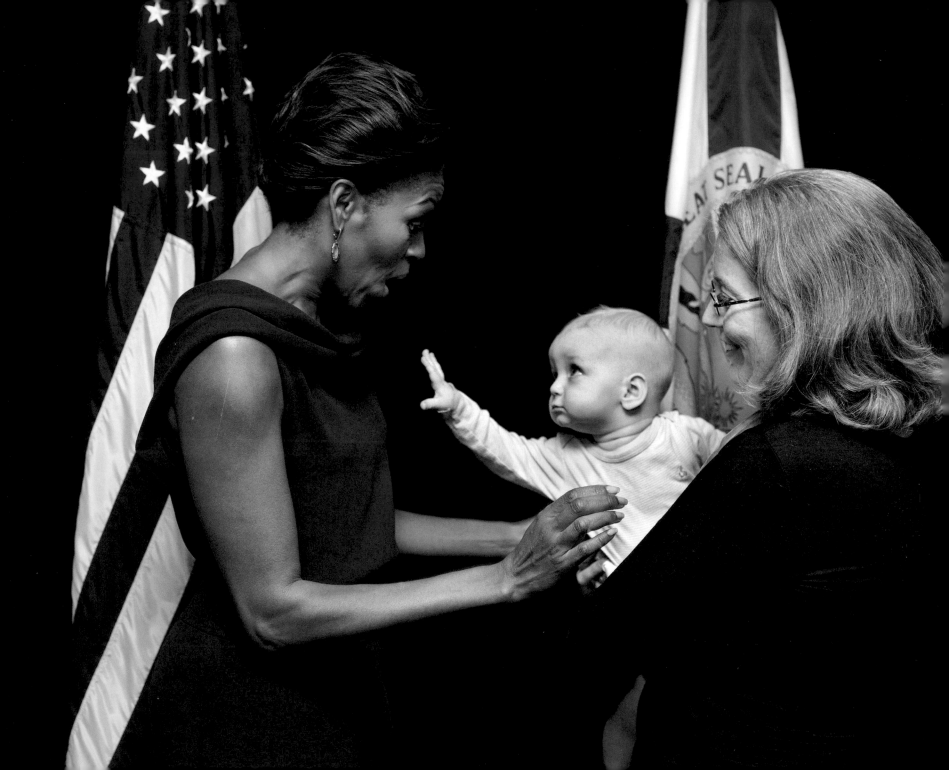

"HOPE IS NECESSARY.

It is a necessary concept.
What do you give your kids
if you can't give them hope?"

—Interview with Oprah Winfrey, *CBS*, December 19, 2016

"THROW THE SCHOOL GATES OPEN TO **GIRLS EVERYWHERE.**"

—Op-Ed, *Financial Times*, June 15, 2015

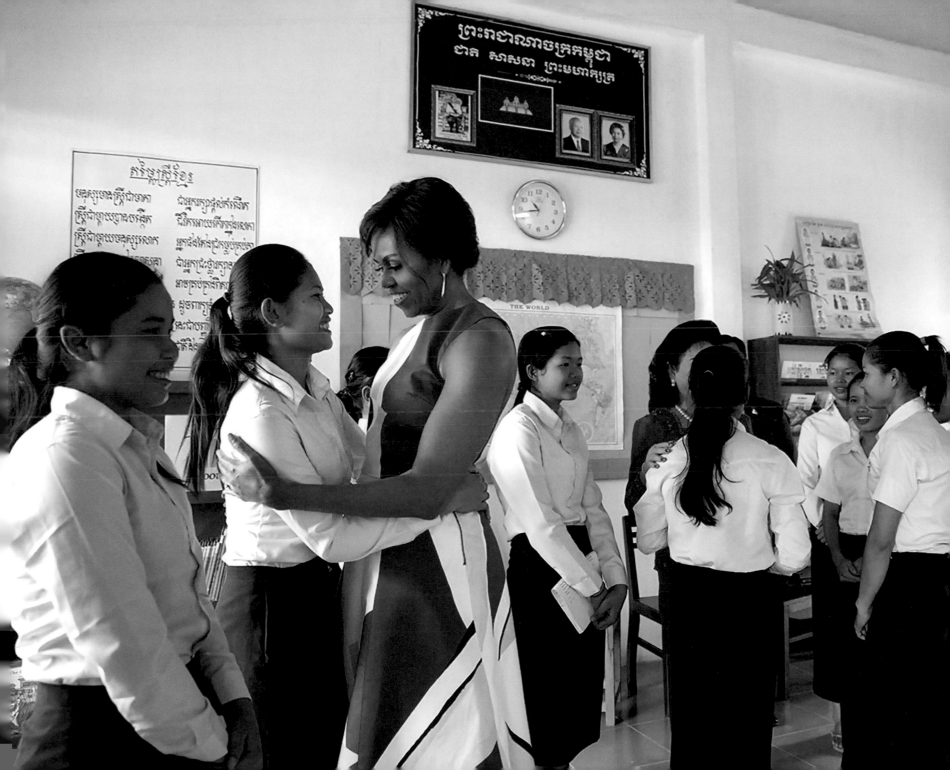

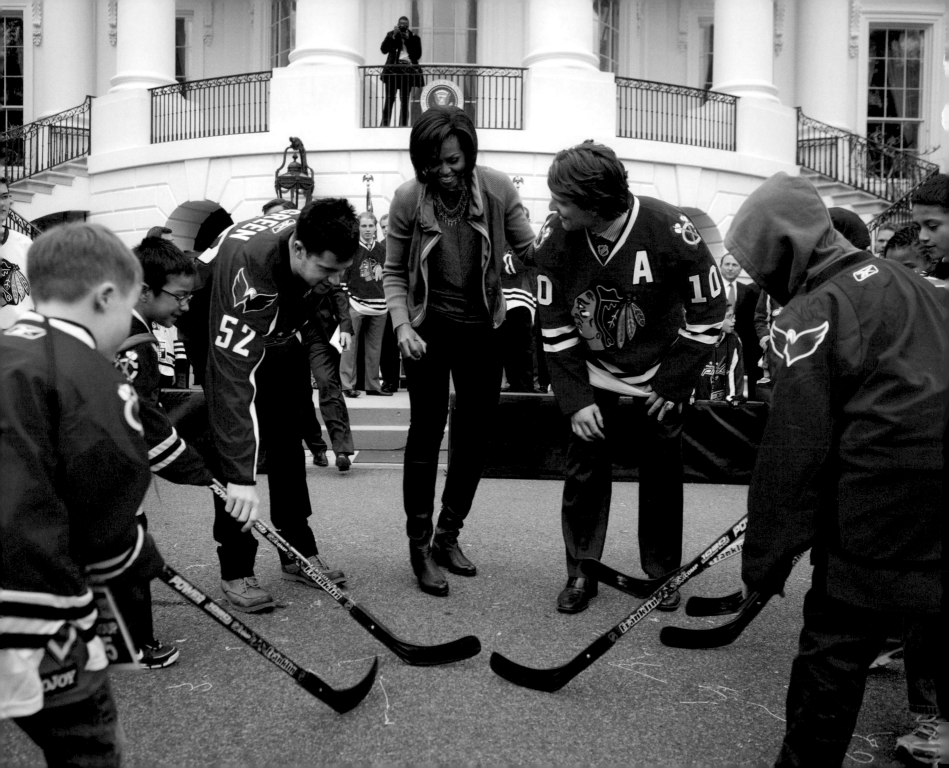

" The challenge that this country faces is how are we, as individuals in this society, going to change? **WHAT ARE WE GOING TO DO DIFFERENTLY?** "

—Interview with Katie Couric, *CBS News*, February 14, 2008

WHEN YOU ARE STRUGGLING AND YOU START THINKING ABOUT GIVING UP, I WANT YOU TO **REMEMBER SOMETHING** . . . AND THAT IS **THE POWER OF HOPE—** THE BELIEF THAT **SOMETHING BETTER IS ALWAYS POSSIBLE** IF YOU'RE WILLING TO **WORK FOR IT** AND **FIGHT FOR IT.**

—Final remarks as First Lady, School Counselor of the Year
Reach Higher Event, January 6, 2017

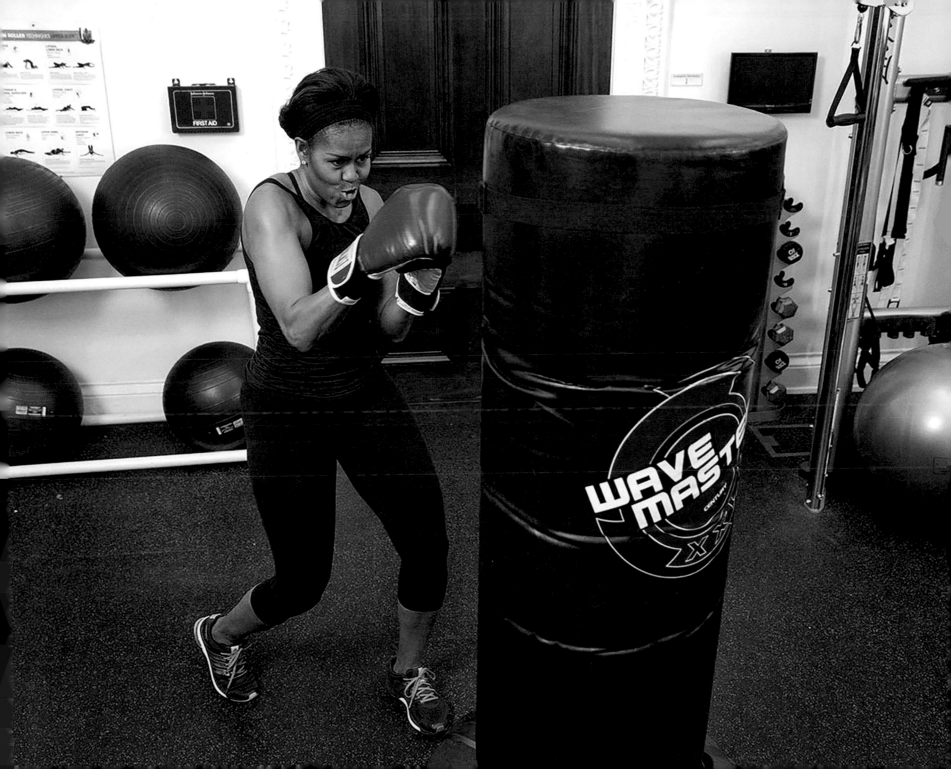

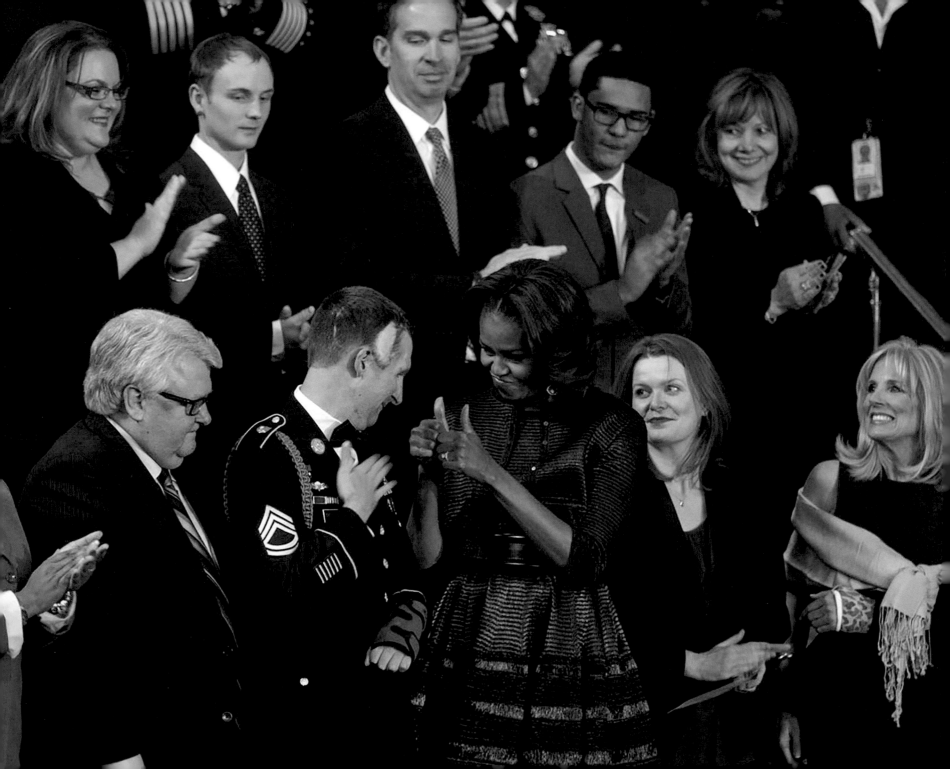

"Every day, the people I meet inspire me...

HOW BLESSED WE ARE

to live in the greatest nation on earth."

—Democratic National Convention, September 4, 2012

"SO THAT'S WHAT I TRY TO DO WITH MY INTERACTIONS: A HUG, A TOUCH. IT'S LIKE MUSIC. **IT'S LIKE FRIENDSHIP.**"

—Interview with *Vogue*, November 11, 2016

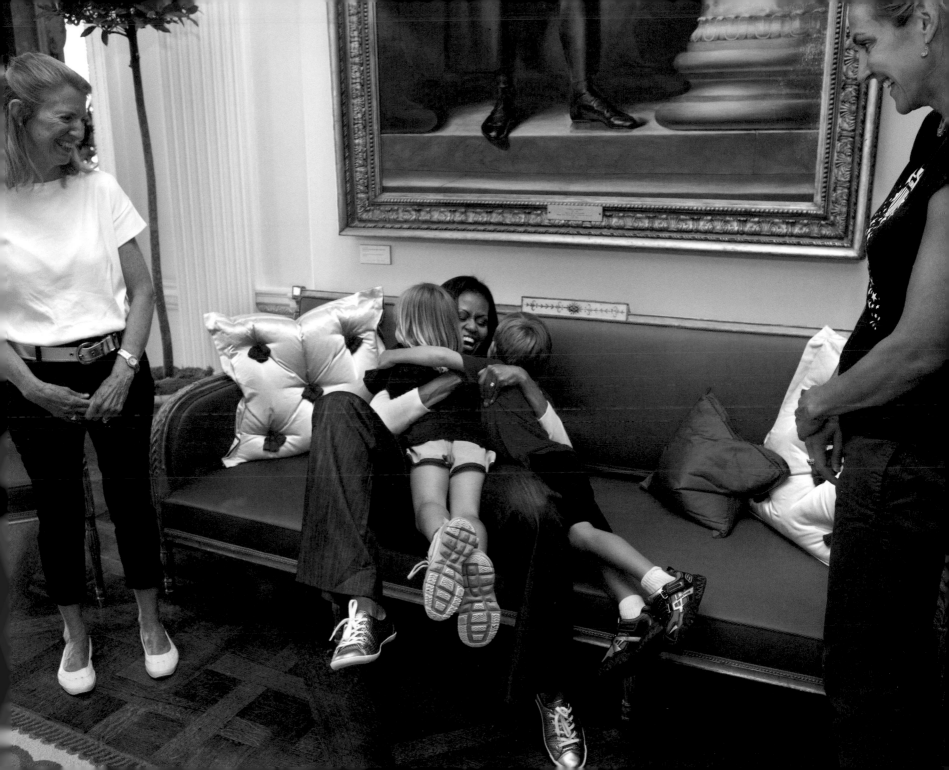

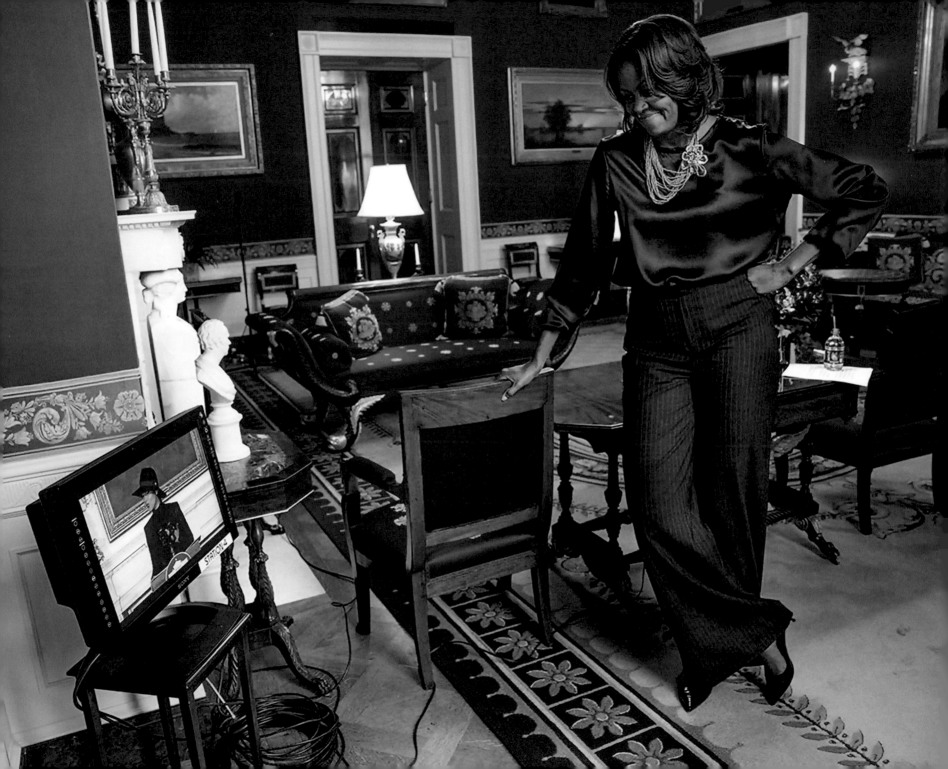

"LEAD BY EXAMPLE WITH HOPE, NEVER FEAR, AND KNOW THAT I WILL BE WITH YOU, ROOTING FOR YOU AND WORKING TO SUPPORT YOU **FOR THE REST OF MY LIFE.**"

—Final remarks as First Lady, School Counselor of the Year
Reach Higher Event, January 6, 2017

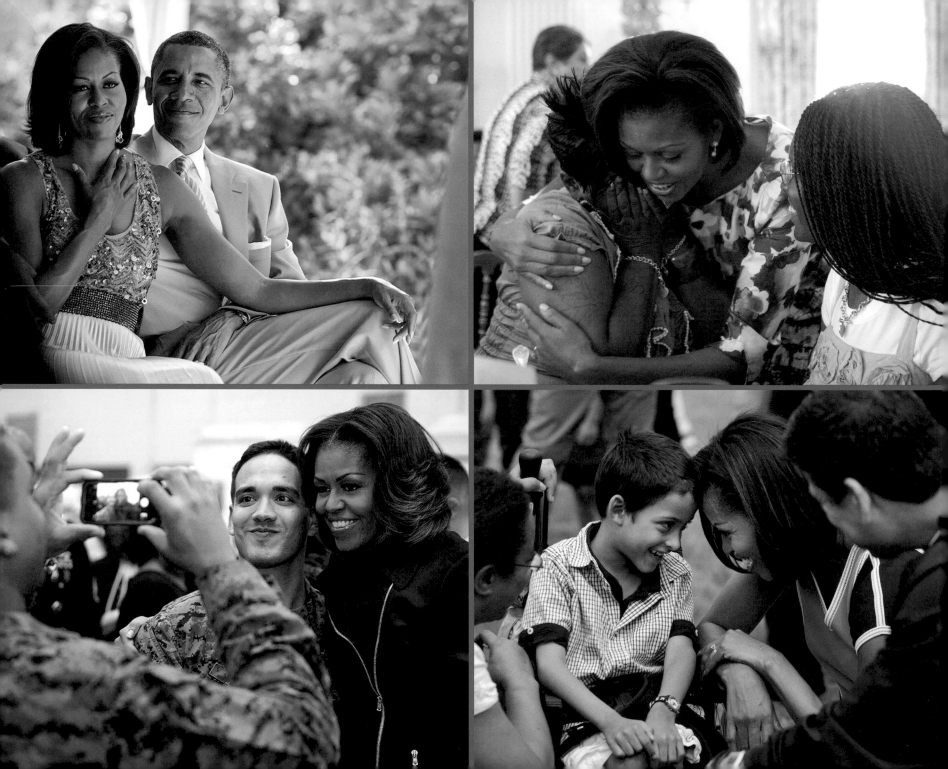

HONOR

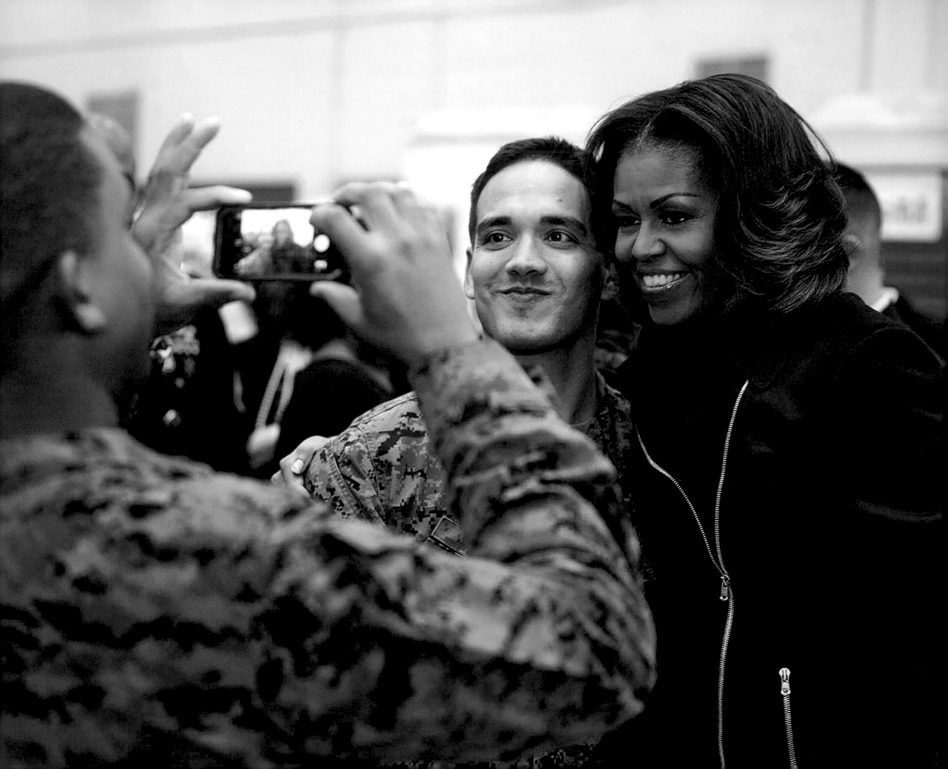

"YOU CANNOT TAKE YOUR FREEDOMS FOR GRANTED.

Just like generations who have come before you, YOU HAVE TO DO YOUR PART TO PRESERVE AND PROTECT THOSE FREEDOMS. "

—Final remarks as First Lady, School Counselor of the Year
Reach Higher Event, January 6, 2017

MEN WHO ARE TRULY ROLE MODELS— DON'T NEED TO PUT DOWN WOMEN TO MAKE THEMSELVES FEEL POWERFUL. PEOPLE WHO ARE TRULY STRONG LIFT OTHERS UP. PEOPLE WHO ARE TRULY POWERFUL BRING OTHERS TOGETHER.

—Hillary for America Campaign Event, October 13, 2016

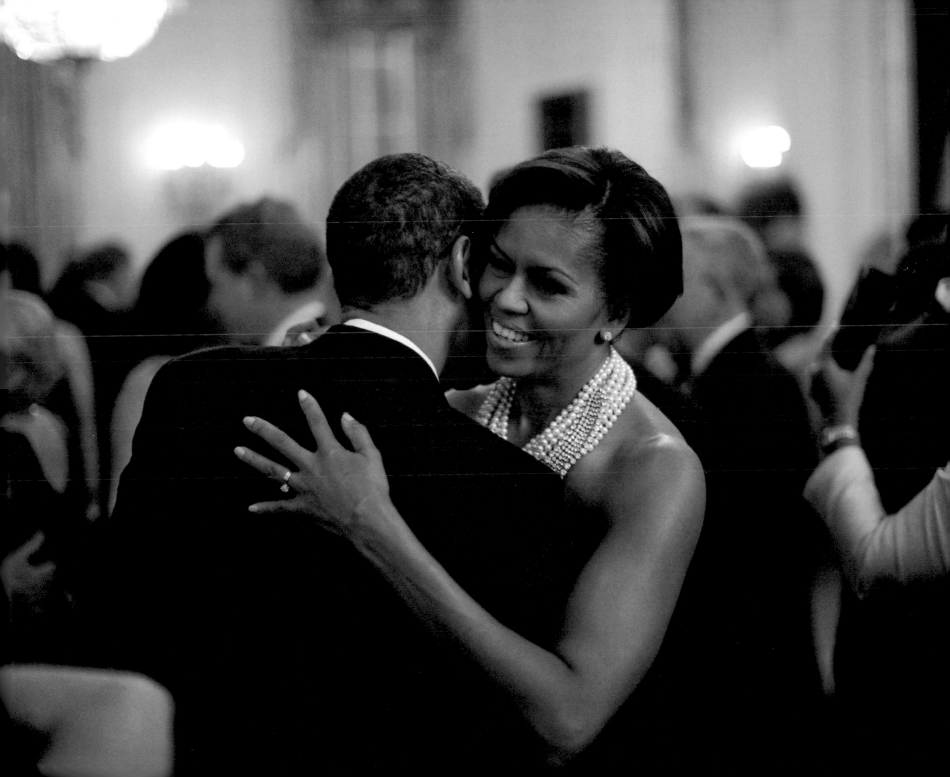

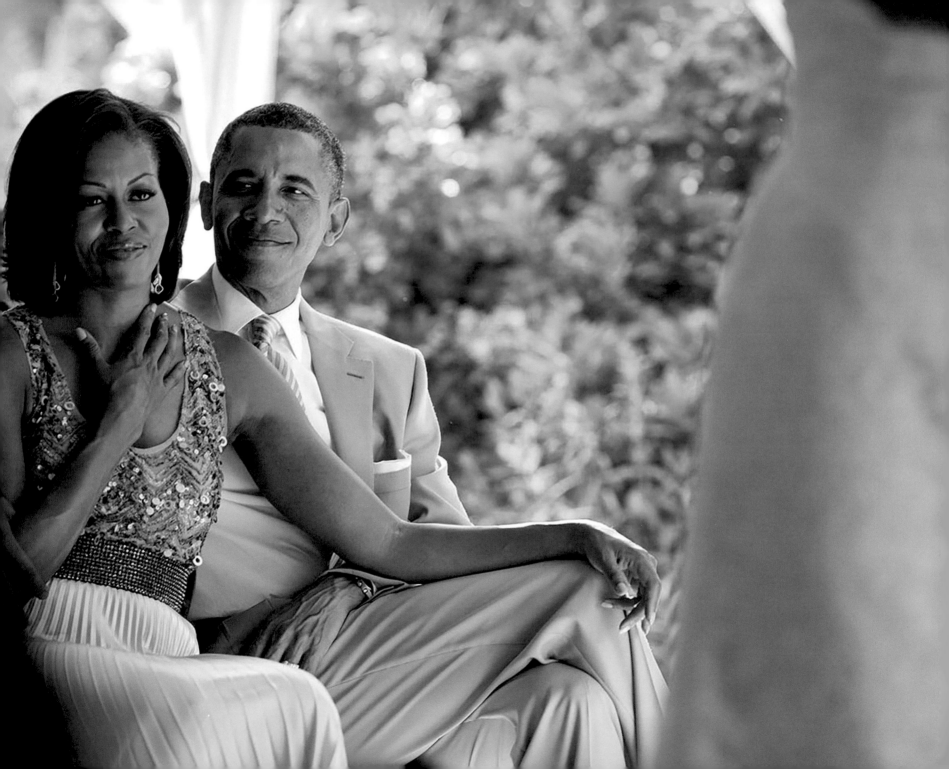

> **IF PROUD AMERICANS CAN** BE WHO THEY ARE AND BOLDLY **STAND AT THE ALTAR** WITH WHO THEY LOVE THEN SURELY, **SURELY WE CAN GIVE EVERYONE IN THIS COUNTRY A FAIR CHANCE** AT THAT GREAT AMERICAN DREAM. "

—Democratic National Convention, September 4, 2012

> That is **THE STORY OF THIS COUNTRY. . .** the story of **GENERATIONS OF PEOPLE** who felt the lash of bondage, the shame of servitude, the sting of segregation, but **WHO KEPT ON STRIVING AND HOPING AND DOING WHAT NEEDED TO BE DONE** so that today, I wake up every morning in a house that was built by slaves—and I watch my daughters—two beautiful, intelligent, black young women—playing with their dogs on the White House lawn.

—Democratic National Convention, July 25, 2016

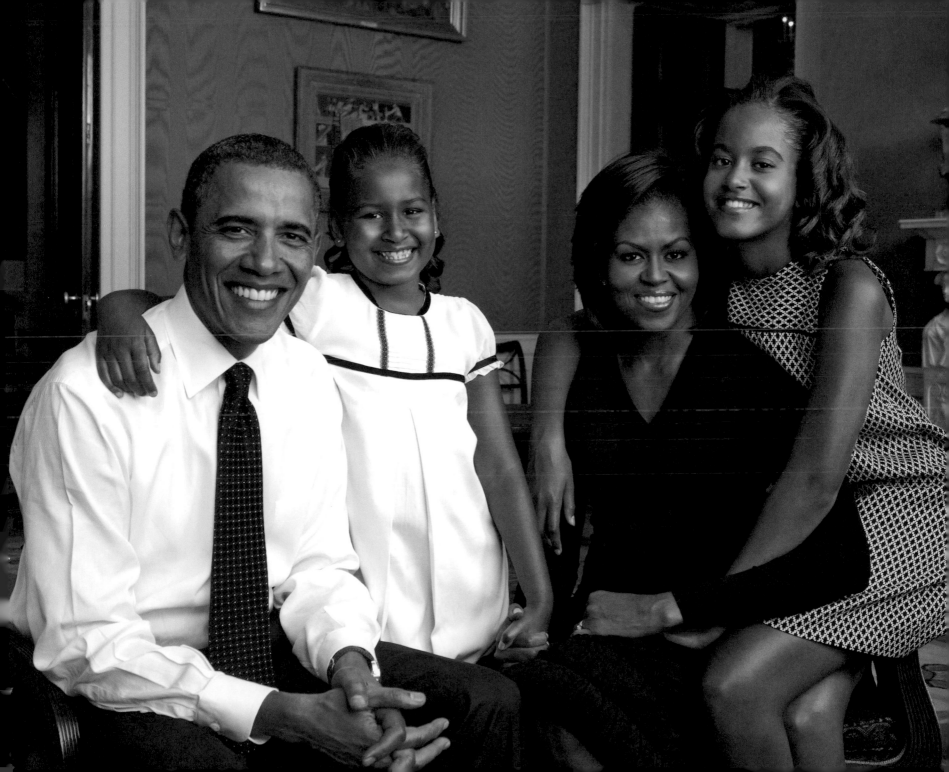

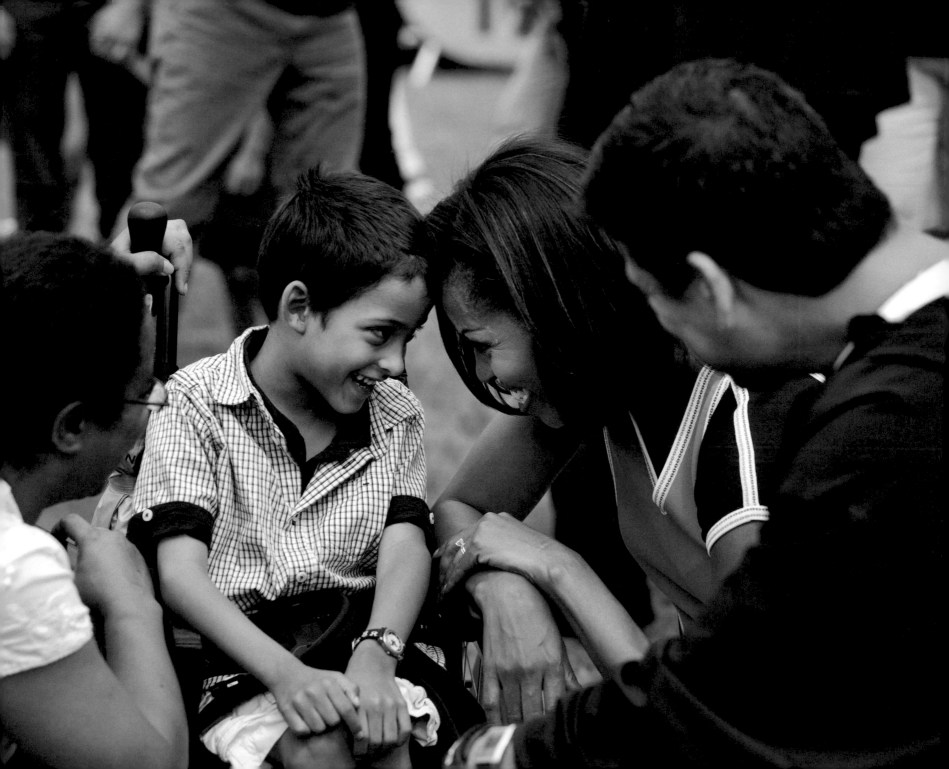

"YOU TOO,
WITH THESE VALUES,
CAN CONTROL
YOUR OWN DESTINY.
YOU TOO, CAN
PAVE THE WAY."

—Elizabeth Garrett Anderson School, April 2, 2009

"YOU HAVE A RIGHT TO

BE EXACTLY WHO YOU ARE.

But I also want to be very clear:

This right isn't just handed to you.

No, this right has to be

earned every single day. "

—Final remarks as First Lady, School Counselor of the Year
Reach Higher Event, January 6, 2017

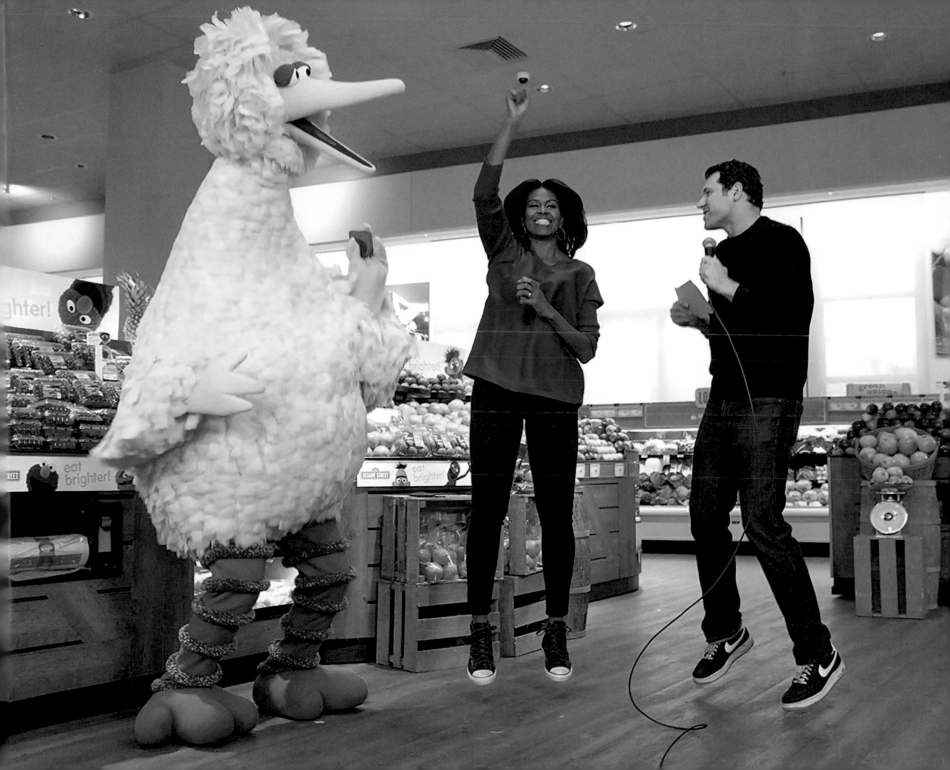

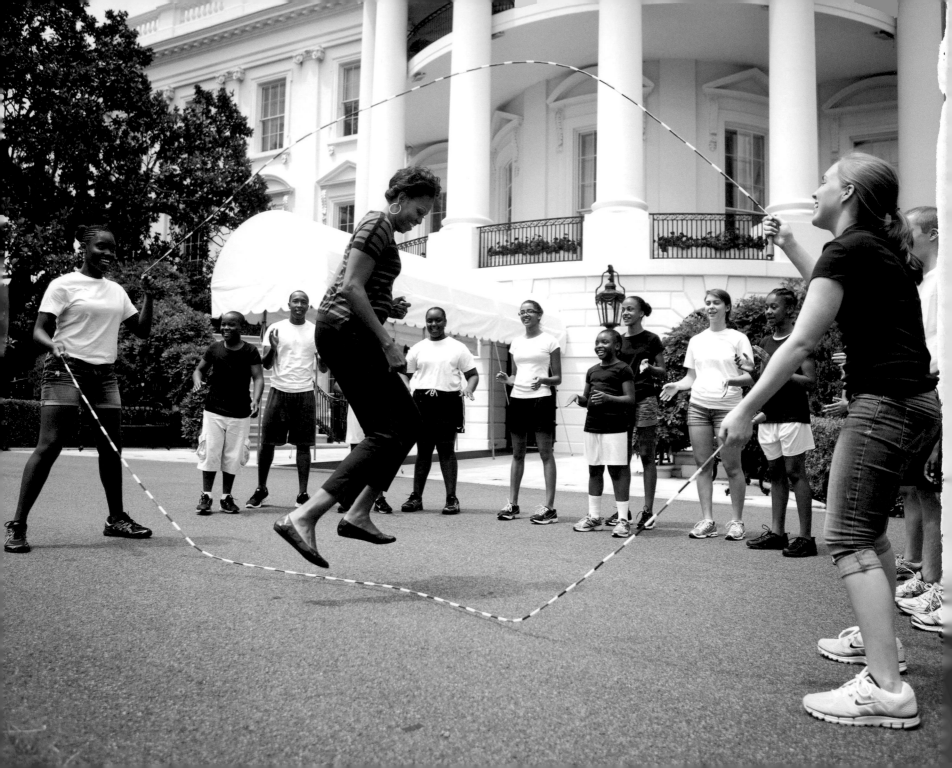

"FEAR IS A USELESS EMOTION. **DON'T EVER MAKE DECISIONS BASED ON FEAR.** MAKE DECISIONS BASED ON **HOPE AND POSSIBILITY.** MAKE DECISIONS BASED ON **WHAT SHOULD HAPPEN,** NOT WHAT SHOULDN'T."

—Phoenix, Arizona, campaign fundraiser, June 3, 2008

"If you or your parents are **IMMIGRANTS**, know that **YOU ARE PART OF A PROUD AMERICAN TRADITION—** the infusion of new cultures, talents and ideas, generation after generation, **THAT HAS MADE US THE GREATEST COUNTRY ON EARTH.** "

—Final remarks as First Lady, School Counselor of the Year
Reach Higher Event, January 6, 2017

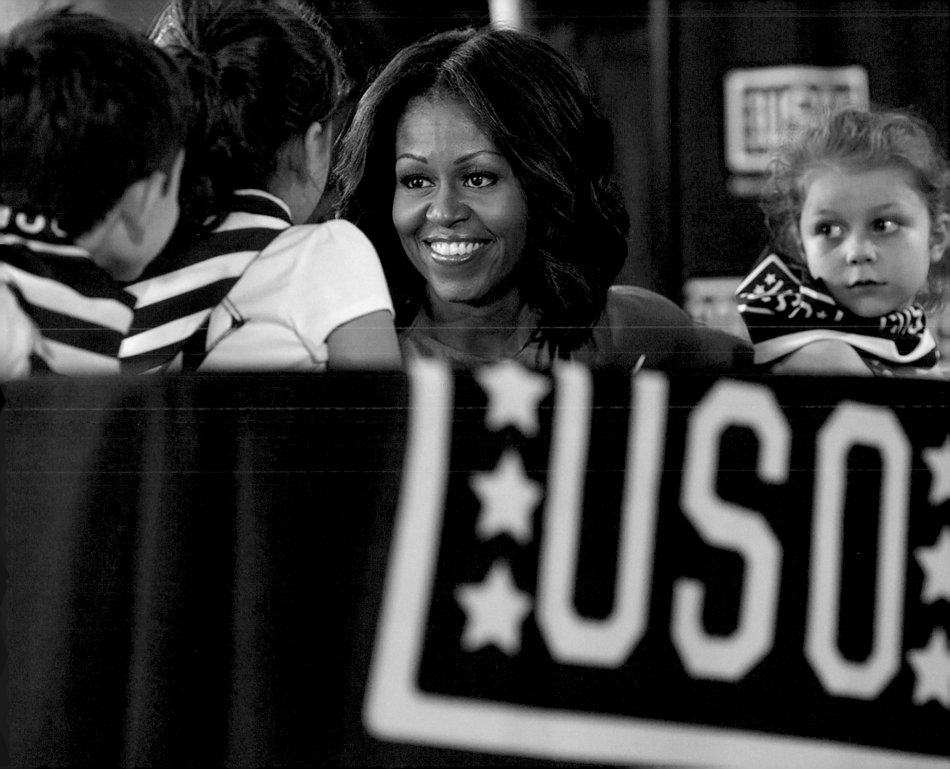

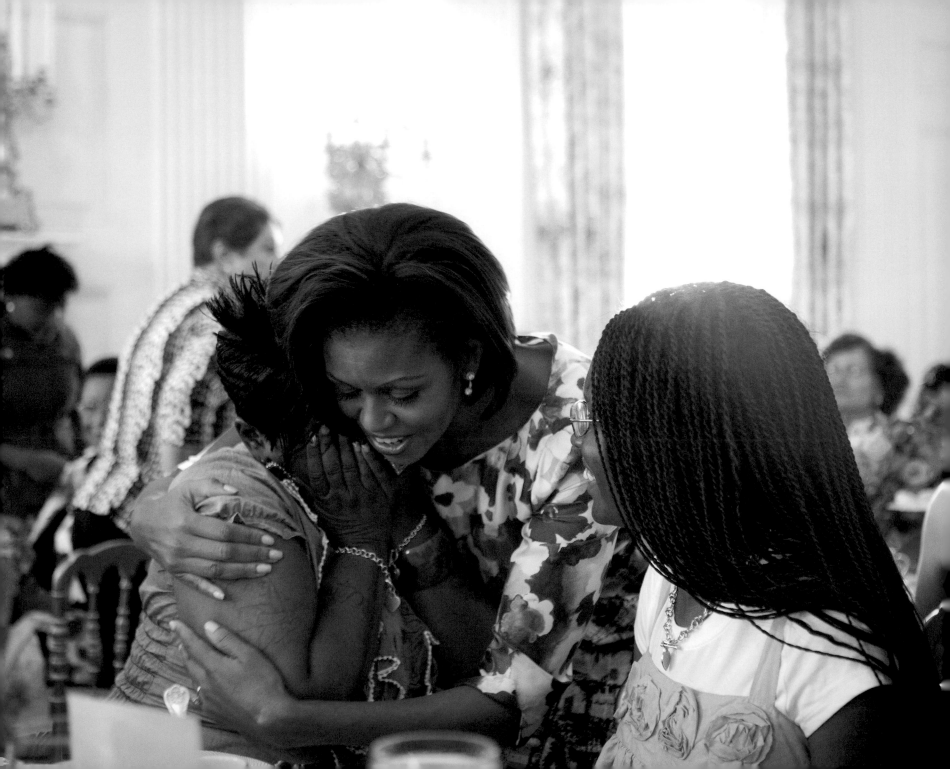

> " Barack and I were raised with so many of the same values, like you **WORK HARD FOR WHAT YOU WANT IN LIFE.** That your word is your bond; that you do what you say you're going to do. That you **TREAT PEOPLE WITH DIGNITY** and respect, even if you don't know them and even if you don't agree with them. "

—Democratic National Convention, August 25, 2008

> **"THERE ARE STILL SO MANY CAUSES WORTH SACRIFICING FOR. THERE IS STILL SO MUCH HISTORY YET TO BE MADE."**

—Young African Women Leaders Forum, June 22, 2011

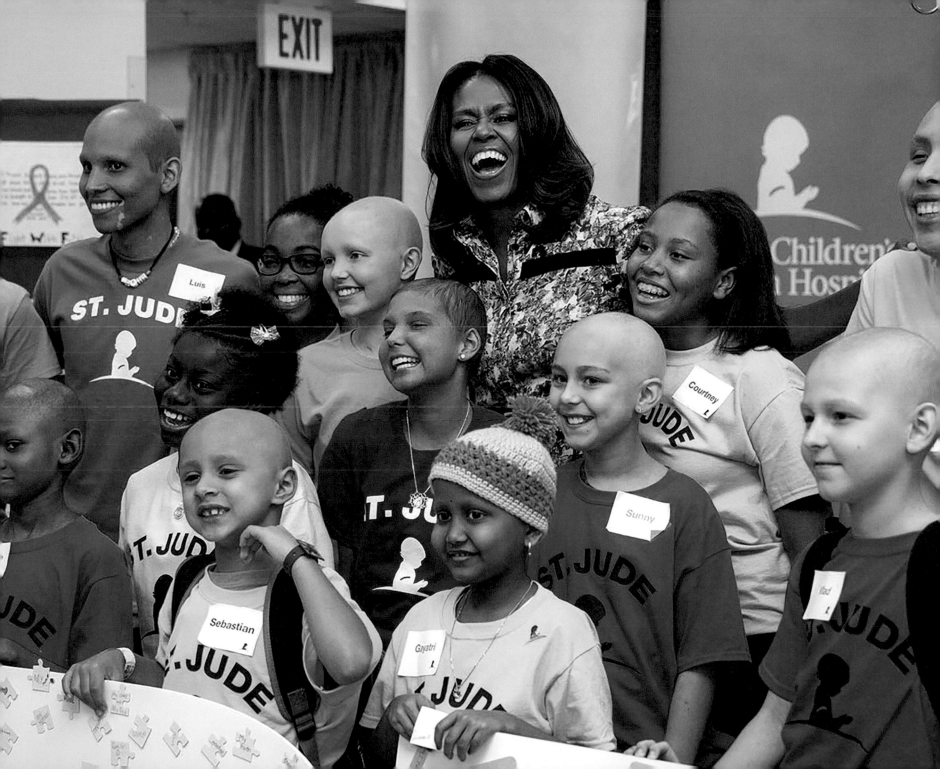

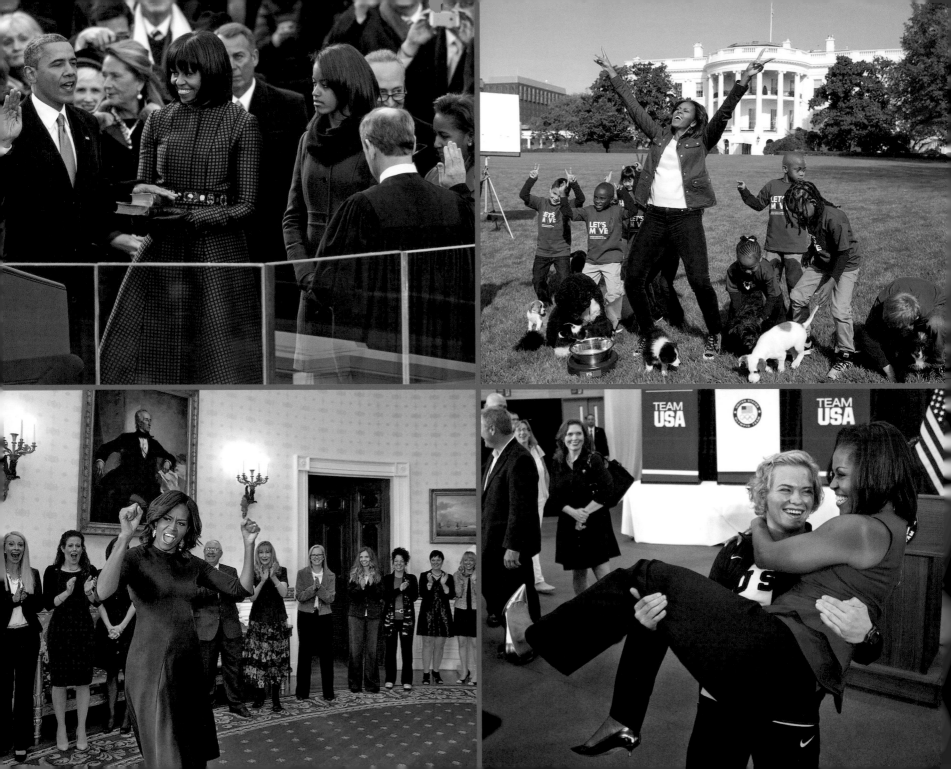

HIGH

> **"OUR DIVERSITIES OF FAITHS**
> and colors and creeds—that is
> not a threat to who we are,
> **IT MAKES US WHO WE ARE."**

—Final remarks as First Lady, School Counselor of the Year
Reach Higher Event, January 6, 2017

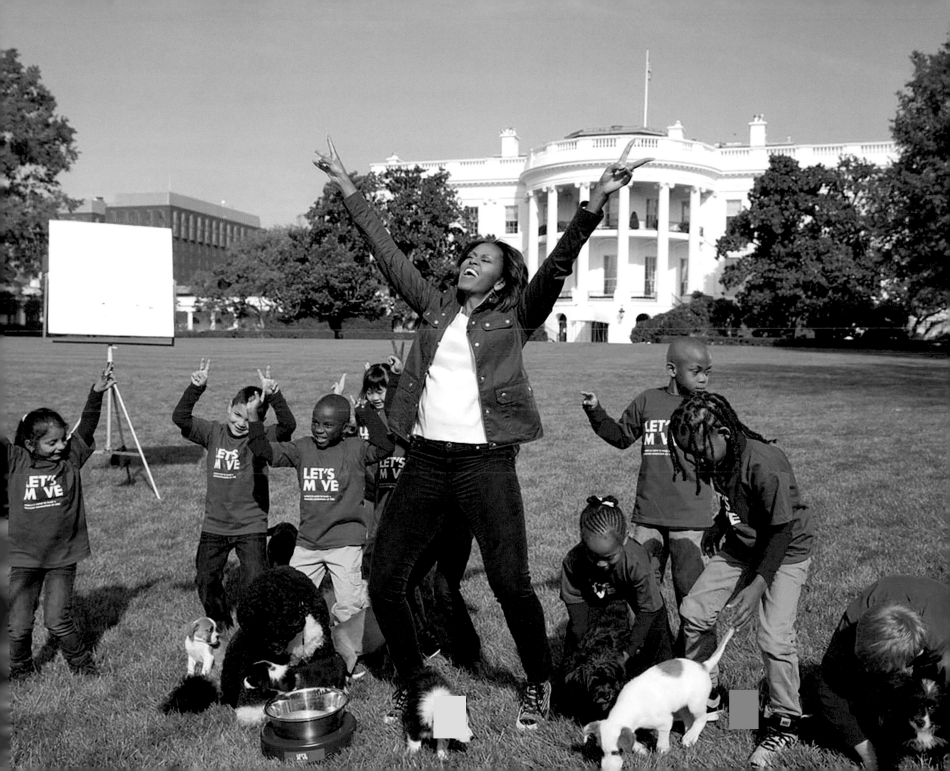

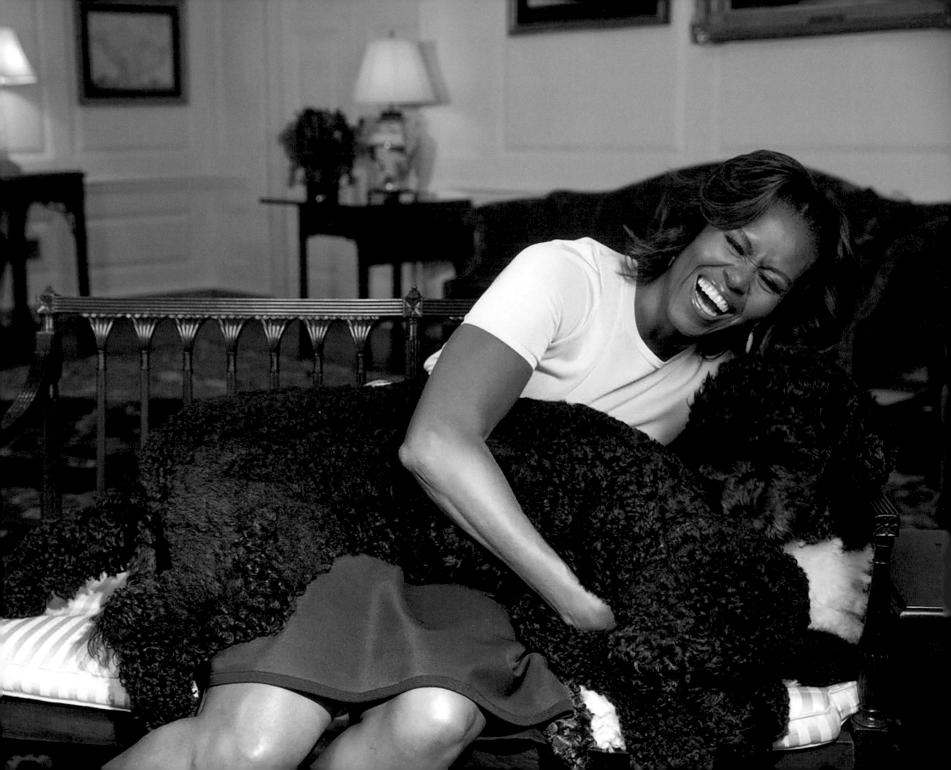

"WHEN I HEAR ABOUT NEGATIVE AND FALSE ATTACKS, I REALLY DON'T INVEST ANY ENERGY IN THEM, BECAUSE **I KNOW WHO I AM.**"

—Interview with *Marie Claire*, October 22, 2008

> **"** What I have never been afraid of is to be a little silly... **GET THEM TO LAUGH,** then you **GET THEM TO LISTEN. "**

—Interview with *Variety*, August 23, 2016

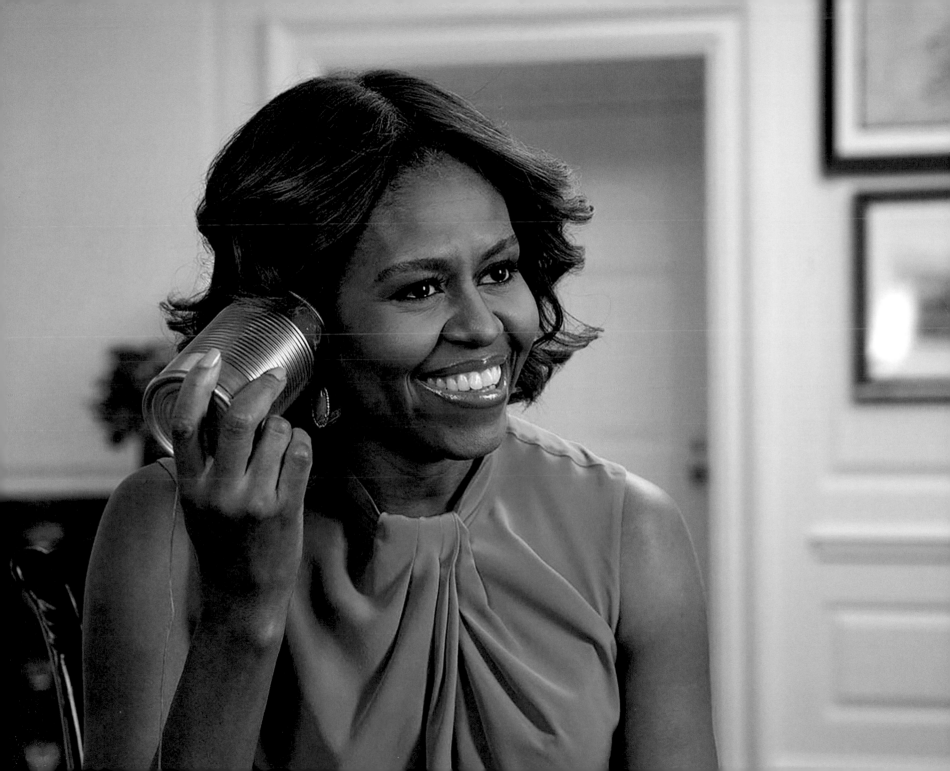

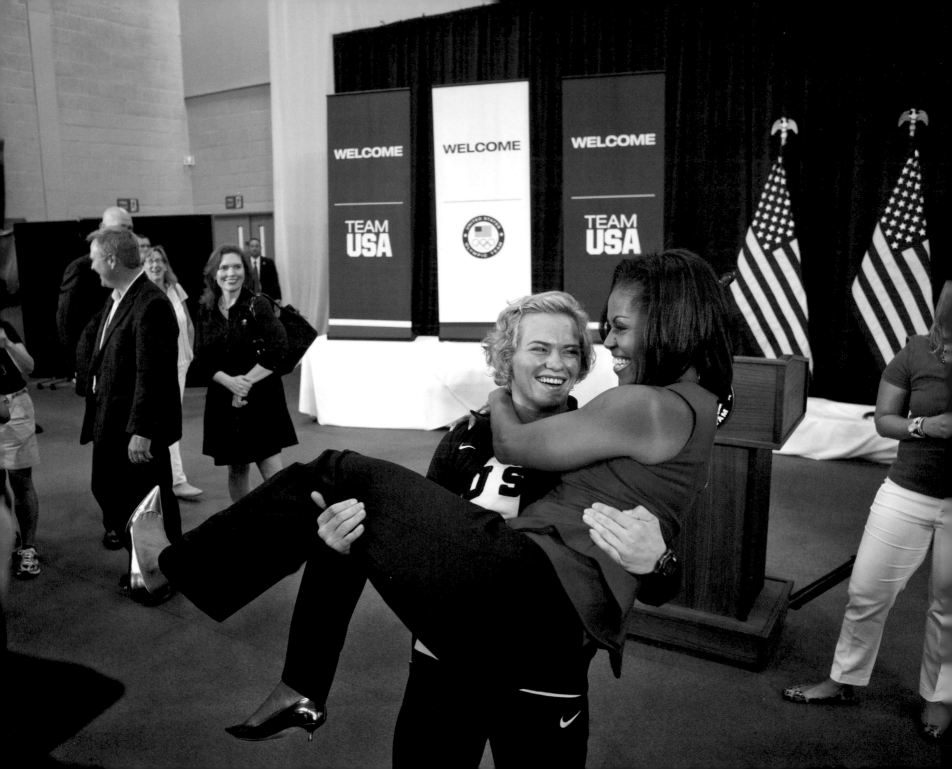

> **DO WHAT MAKES YOU FEEL GOOD,** because there'll always be someone who thinks you should do it differently. Whether **YOUR CHOICES** are hits or misses, at least **THEY'RE YOUR OWN.**

—Interview with Liz Vaccariello, *Prevention*, October 5, 2009

> " I WANT SOMEONE WITH THE **PROVEN STRENGTH TO PERSEVERE,** someone WHO KNOWS THIS JOB AND TAKES IT SERIOUSLY, someone who understands that the issues a president faces are not black and white and cannot be boiled down to 140 characters. "

—Democratic National Convention, July 25, 2016

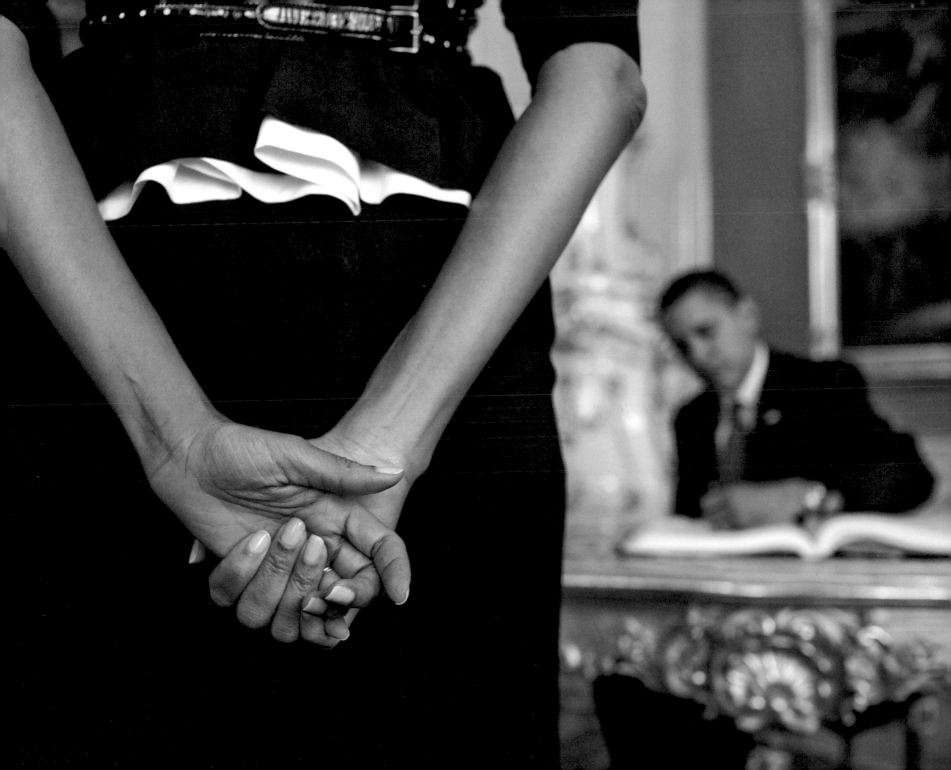

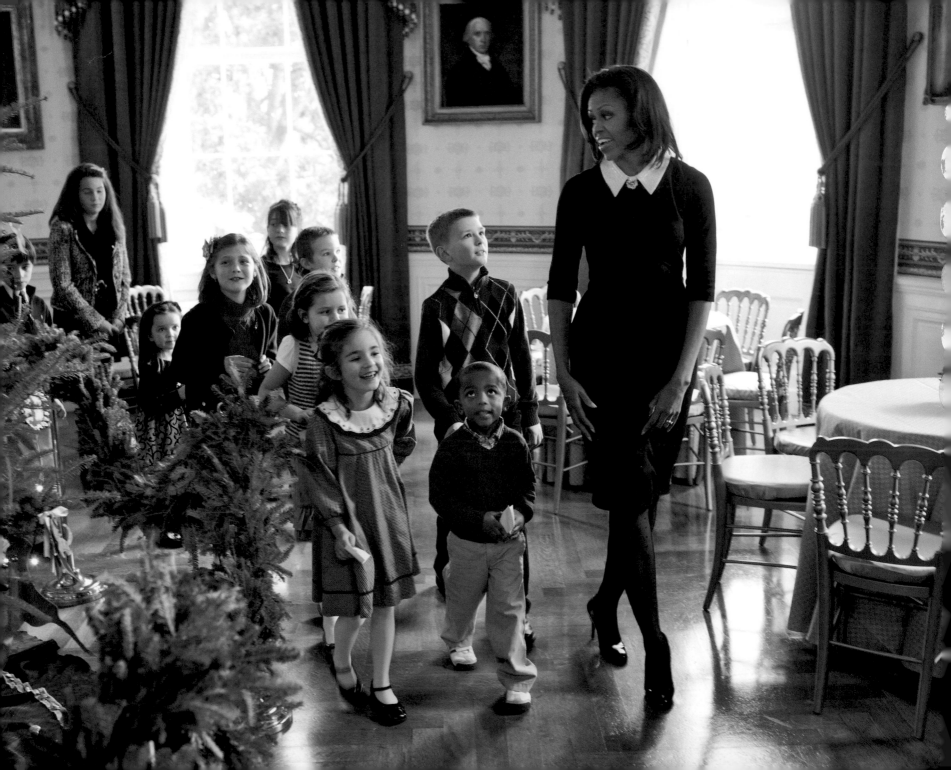

"IT IS OUR FUNDAMENTAL BELIEF IN THE POWER OF HOPE THAT HAS ALLOWED US TO RISE ABOVE

the voices of doubt and division, of anger and fear that we have faced in our own lives and in the life of this country."

—Final remarks as First Lady, School Counselor of the Year
Reach Higher Event, January 6, 2017

"If you want to have a say in your community… then you've got to be involved. You got to be at the table. You've got to

VOTE, VOTE, VOTE, VOTE.

That's it; that's the way we move forward. That's how we make progress

FOR OURSELVES AND FOR OUR COUNTRY."

—Tuskegee University, May 9, 2015

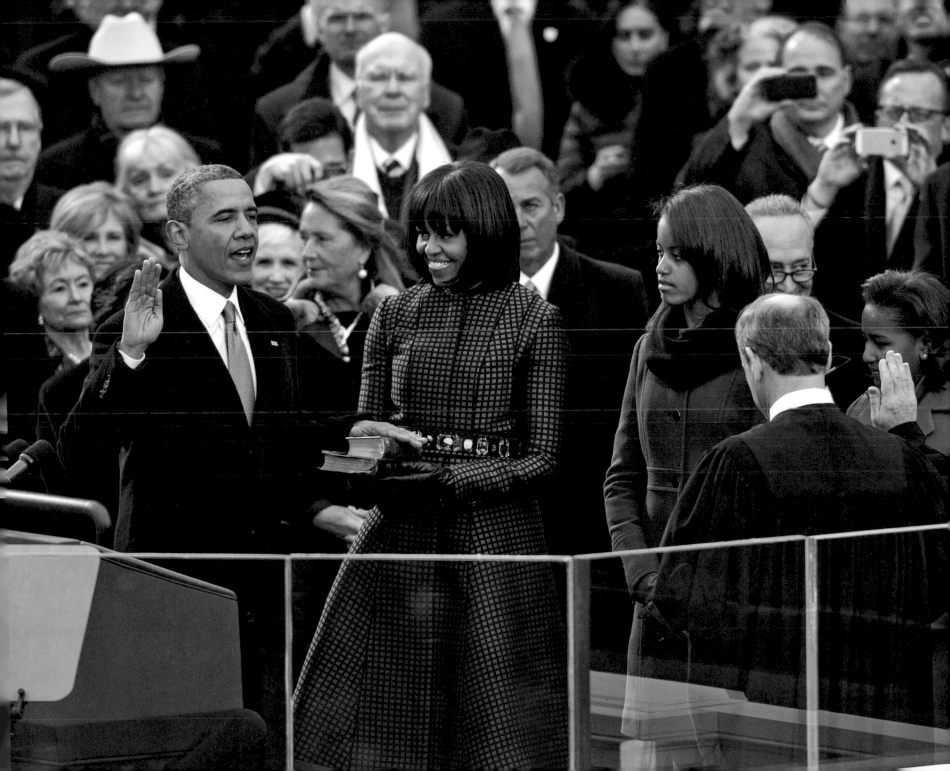

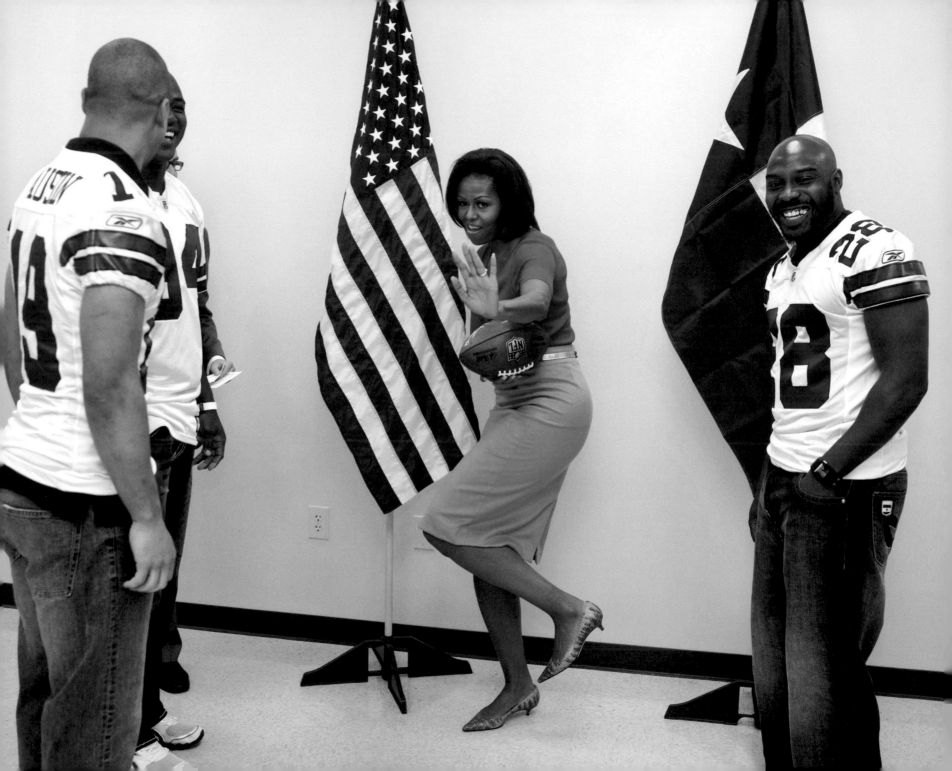

"You don't have to say anything to the haters. You don't have to acknowledge them at all. You just wake up every morning and **BE THE BEST YOU YOU CAN BE.** And that tends to shut them up."

—Conversation with Oprah Winfrey,
United State of Women Summit, June 14, 2016

> **"** Empower yourselves
> with a good education, then
> # GET OUT THERE AND
> # USE THAT EDUCATION
> to build a country worthy
> of your boundless promise. **"**

—Final remarks as First Lady, School Counselor of the Year
Reach Higher Event, January 6, 2017

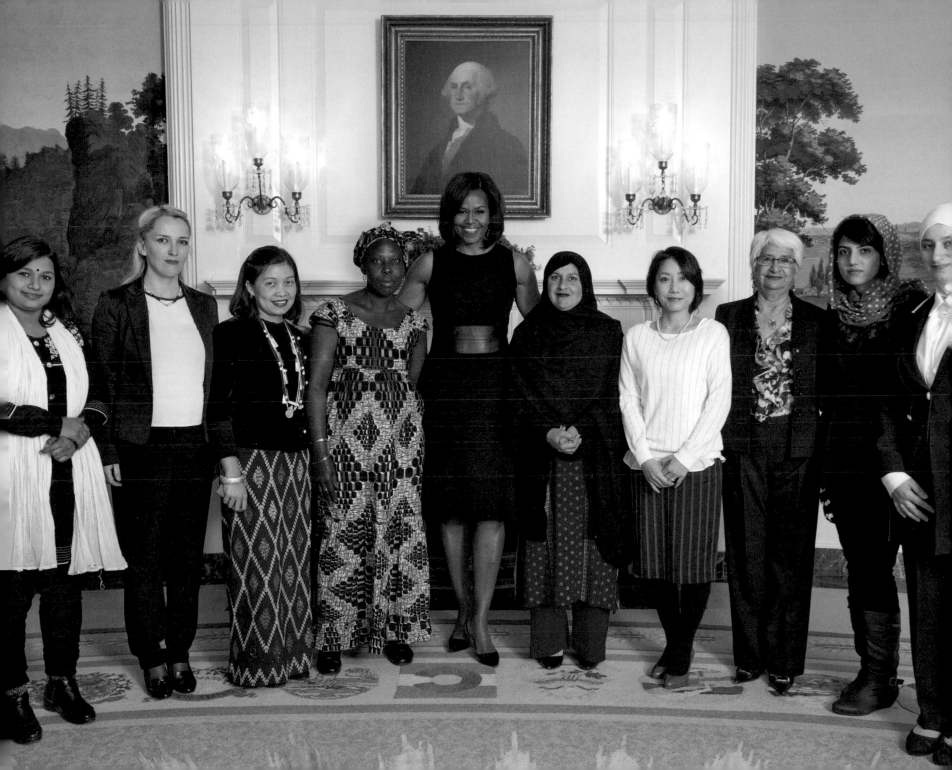

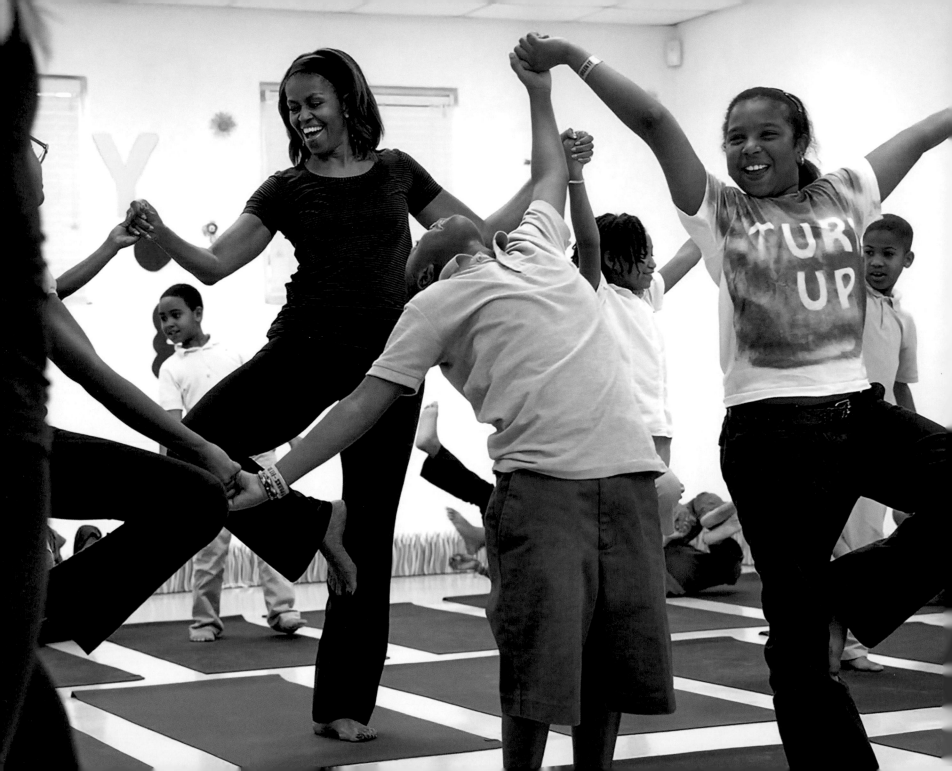

"THIS TIME, WE DECIDED TO **STOP DOUBTING** AND TO **START DREAMING.**"

—Democratic National Convention, August 25, 2008

"I CAN'T WAIT TO SEE HOW HIGH YOU SOAR."

—Tuskegee University, May 9, 2015

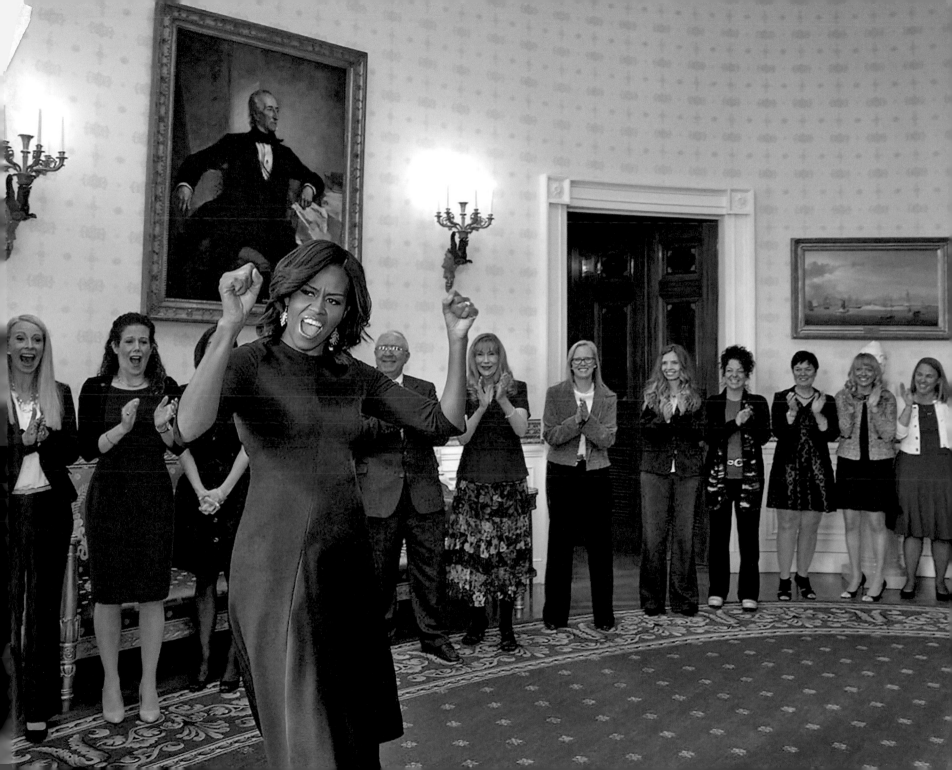

"WHEN THEY GO LOW, WE GO HIGH."

—Democratic National Convention, July 25, 2016